V77

John House

MONET

PHAIDON

The author and publishers would like to thank all those museum authorities and private owners who have kindly allowed works in their possession to be reproduced.

Phaidon Press Limited, Littlegate House, St Ebbe's Street, Oxford
Published in the United States of America by E.P. Dutton, New York

First published 1977

© *1977 by Phaidon Press Limited*

ISBN 0 7148 1809 7
Library of Congress Catalog Card Number: 77-78376

Printed in Great Britain

MONET

When the paintings of the Impressionists first appeared publicly in the 1870s, they created an entirely new type of exhibition picture – small, informal in composition, freely and spontaneously painted, showing everyday scenes treated in clear bright colour. At the time, the Impressionist vision seemed unintelligible, the antithesis of art. Yet by the turn of the century, this way of painting had swept the western world, and the original masters of the movement in Paris had become rich and famous. Today, our ideas of landscape painting, and even the ways in which we see the world itself, are conditioned by the Impressionist vision, which we accept without question as a 'natural' way of seeing and representing our surroundings.

More than any other single artist, Claude Monet was the creator of this new idea of painting; his scenes of sailing boats at Argenteuil are synonymous with the popular idea of Impressionism (Plates 16, 17). But this type of painting is only one of the many facets of Monet's work; in a career of over sixty years, he pursued his basic aim with an originality and an intensity that rarely flagged. This aim he summarized in 1926, the year of his death, in terms he could have used at any time since the 1860s: 'I have always had a horror of theories; my only virtue is to have painted directly in front of nature, while trying to depict the impressions made on me by the most fleeting effects.' This central preoccupation led Monet through a sequence of experiments in which he continuously expanded his range of effects. It also forced him to explore with ever greater concentration a basic concern of all landscapists – to find ways of reconciling the perception of three dimensions with the demands of a two-dimensional canvas – to make a picture which is coherent in terms of coloured paint and brushstrokes, out of experiences of objects, distance and atmosphere. Monet's greatness as a landscapist lies in the completeness of the reconciliation which he achieved – in the ways in which he made the surface relationships within his paintings express the forms and forces of nature.

Claude Monet was born in Paris in 1840, but about five years later the family moved to Le Havre, where Monet's father was to work as a wholesale grocer. Monet's childhood at Le Havre, where the River Seine meets the sea, established his lifelong obsessions as an artist; he always lived by the Seine and found in the Seine valley most of his favourite motifs, and when he travelled he usually explored and painted the coast, particularly in Normandy. However, Monet did not immediately begin to sketch the natural scenes around him; his artistic beginnings were as a caricaturist – in his teens he earned his pocket-money by clever comic drawings of the people of Le Havre. His initiation into painting nature he always attributed to his meeting with the artist Eugène Boudin (1824-98), then little known and working in Le Havre; some time around 1857, Boudin took Monet with him one day when he went to paint in the countryside, and, Monet said later, 'it was as if a veil was torn from my eyes; I understood what painting could be.'

Thenceforth, landscape became his prime concern. In 1859, his caricatures paid for a trip to Paris, where he met Boudin's former teacher, the landscapist and animal-painter Constant Troyon (1810-65), and also made his first contacts with the Realist artists and writers in Paris; he saw, but did not yet meet, the high priest of Realist painting, Gustave

Courbet (1819-77). Early in 1861, Monet drew an unlucky number in the lottery for military service, and chose to go with the *Chasseurs d'Afrique* to Algeria, where, he later said, he received 'impressions of light and colour' which 'contained the germ of my future researches'.

However, after only a year, he was back in France on sick leave, and his father agreed to buy him out of the remainder of his service, provided he would undergo a formal training as an artist with an established master in Paris. In the autumn of 1862, he entered the studio of the Neo-Classical painter Charles Gleyre (1806-74), where he continued to work, in a rather desultory fashion, probably until the spring of 1864.

During these years, though, his most important encounters were outside his academic studies, and it was these encounters that guided the development of his painting during the first years of his career as an independent artist. In the summer of 1862, he met the Dutch landscapist Johan Barthold Jongkind (1819-91) near Le Havre: 'From then on, he was my real master; to him I owed the final education of my eye.' Jongkind was the model for Monet's first seascapes of 1864, when the two men were together on the coast; Monet's two marines exhibited in 1865 (Plate 1 is one of them), though much larger than Jongkind's contemporary canvases, are virtual tributes to the Dutchman's style in their fluent yet delicate handling, which suggests natural detail and the fall of light without resorting to dry and overprecise description.

These paintings were shown at the Salon – the French equivalent of the Royal Academy and main forum for conventional art – and were well received by the critics, a success that encouraged Monet to undertake a more ambitious enterprise; for this, though, he turned to a different inspiration. He decided to execute a vast picnic scene, on a canvas twenty feet long, which in scale and in the overt modernity of its grouping would outshine the *Déjeuner sur l'Herbe* by Edouard Manet (1832-83), which had caused such a sensation at the Salon des Refusés – a counter-Salon set up for artists refused by the Salon itself – in 1863. Since this *succès de scandale*, Manet and his work had become the rallying point for younger artists turning against the canons of the Salon, which favoured meticulous technique and subjects taken from history and mythology. Monet never completed his own *Déjeuner* to his satisfaction, and it survives only in fragments (the left-hand section is shown in Plate 2); in its bold emphatic brushwork it echoes Manet, but the informality of its composition and its sparkling light-effects are quite unlike the old-masterly grouping and studio lighting of Manet's picture. Paradoxically, though, when Monet abandoned the large version of his painting, he quickly executed for the Salon of 1866 a life-size portrait of his mistress Camille (Plate 4), which owed more to Manet than any of his other major paintings. This led Manet to utter bitter quips about Monet aping both his style and his name; but the two men seem to have met in 1866, and later became firm friends. During this period, too, Monet got to know Courbet, who became a strong supporter of his, though holding different ideas about the technique of painting; Courbet generally worked on a dark-toned canvas-priming, and built up his paint thickly towards the highlights, while Monet increasingly favoured a light-toned priming, which helped him to achieve the luminosity which he sought in his light-effects.

In Gleyre's studio, Monet had met three fellow-students with ideas congenial to his – Frédéric Bazille (1841-70), who quickly became a close comrade, Pierre-Auguste Renoir (1841-1919), and Alfred Sisley (1839-99); around 1860, he had first met Camille Pissarro (1830-1903). After the Franco-Prussian War of 1870-1, in which Bazille was killed, these

friends were to become, with Monet, the nucleus of the Impressionist group; they were not so closely linked in the 1860s, but worked together on occasions, and shared a number of interests. They were principally interested in painting landscapes and scenes of modern outdoor life, and wanted their paintings to convey the way in which modern man saw the world around him. Very influential on their ideas about modernity was Charles Baudelaire's essay about the graphic artist Constantin Guys, *The Painter of Modern Life* (published in 1863), which urged the artist to study closely the fashionable scenes around him, and yet to remain detached from them; such observation, for Baudelaire, best conveyed the 'heroism of modern life'.

One way to preserve the immediacy of what they saw was to paint studies directly from the subject, in the open air; this in itself was nothing new, as French landscapists since the mid-eighteenth century had regularly made notations of natural effects in oils before the motif, but Monet and his friends became increasingly concerned to retain a sense of directness in their finished works. During the 1860s, for the most part, they maintained the traditional distinction between outdoor studies and larger, more highly finished paintings executed in the studio for the Salon, but, after the failure of his *Déjeuner sur l'Herbe*, Monet made one grand attempt to paint a monumental Salon painting out of doors – *Women in the Garden*, which was rejected by the Salon jury in 1867; to paint the top of this eight-foot-high canvas on the spot, Monet had to lower its base into a specially dug ditch. After this, though, he realized that working on this scale was incompatible with the direct methods needed in the open air, and thereafter painted his few large exhibition pictures in the studio.

In the same years, Monet painted many smaller scenes of outdoor subjects, which were probably largely executed on the spot (Plates 3, 6 and 7), though the precise finish of some of them suggests that they were completed at his leisure in the studio. In scenes of Paris and the Normandy coast, he recorded strolling fashionable figures and fishermen and their boats by the sea; the high viewpoints and loosely structured compositions of some of them (Plate 3, for instance) suggest that Monet was aware of other contemporary images of the modern scene, in prints and illustrated magazines, and the groupings in his figure-paintings of the period (such as Plate 2) are reminiscent of fashion-plates. These informal compositions helped Monet to achieve a Baudelairean spirit of detachment from his subjects. *Terrace at Sainte-Adresse* (Plate 6), with its grid-like composition set up by the flag-poles, is, as Monet himself admitted, an early example of the impact that Japanese colour-prints had on him. The new art of photography has been cited as an influence on pictures like these, but contemporary urban photographs are very close in conception to the prints and graphic illustrations of the period, and Monet's paintings, with their crisp handling and clear colour, bear little relationship to the specifically photographic elements in these small monochrome photographs.

During the 1860s, Monet began to use colour differently, moving from the comparatively subdued scheme of *The Pointe de la Hève at Low Tide* (Plate 1) to brighter and more contrasting hues. The posthumous influence of Eugène Delacroix (1799-1863) was of great importance for the development of the Impressionists' colour; his paintings, and his recorded comments published after his death, taught them how juxtaposed areas of contrasting colour could be used to brighten and enliven a whole scene. Monet first put these ideas into practice in sunlight scenes; *Terrace at Sainte-Adresse* (Plate 6) is an early example, with strong contrasts of reds and greens in the flowerbeds, and soft blues in the

open shadows set against the light creamy tones of the highlights.

However, Monet's boldest works of the 1860s were his less finished paintings – notably some stormy seascapes, such as *Stormy Sea at Etretat*, in which he used the brush with great freedom to suggest the textures of the scene, and the studies which he made at La Grenouillère in the summer of 1869 (Plate 8); these studies were meant as preparations for a large painting (now lost) of the scene designed for the Salon of 1870, but, in retrospect, the studies have acquired far greater status than Monet meant for them when they were painted, since in their summary treatment of figures and reflections in water they anticipate many of the features of his work during the next decade. Their degree of finish is quite unlike that of the large figure-painting that Monet submitted unsuccessfully to the Salon in 1870, *Luncheon* (Plate 5); this too is broadly handled, with vigorous separate strokes of the brush, and has a markedly asymmetrical, cut-off composition, but its details are much more clearly defined and precisely described than those in the La Grenouillère studies, and the whole scene has a clear focus instead of revolving round a wide unfocused area of reflections, treated as simple slabs of paint.

The later 1860s saw Monet working at various sites in and around Paris, in the Seine valley, and on the Normandy coast. He relished the artistic debates between writers and painters at the Café Guerbois, which he visited when in Paris, but found it easier to work in solitude, as he wrote to Bazille from the coast in 1868: 'In Paris one is too preoccupied with what one sees and hears, however strong-minded one may be, and what I shall do here will at least have the virtue of being unlike anyone else's work, because it will simply be the expression of my own personal experiences.' He was honeymooning at Trouville with Camille and their son Jean when the Franco-Prussian War broke out in July 1870. To escape conscription, he fled to London, and thence to Holland. The paintings of Turner and Constable have been said to have influenced Monet's work at this time, but his work shows little sign of it; in 1870–1, he could not have seen Constable's freest oil-studies, and the richness of Turner's colour is not echoed in his work of this period. The mistiness and flat simple paint-layers in the background of *The Thames and the Houses of Parliament* (Plate 9) are, if anything, nearer to Whistler's contemporary work, though there is no firm evidence that the two men met at this point. On the Thames and the rivers of Holland (Plate 11), Monet was able to pursue his fascination with reflections in water, seen in different conditions of wind and lighting.

On his return to France at the end of 1871, Monet settled at Argenteuil, a village on the Seine just outside Paris, which was famous for its boating and regattas; here he made his base until the beginning of 1878. Many of Monet's friends came to paint with him there – Sisley, Renoir and Manet among them – and it is the long sequence of paintings executed in and around Argenteuil which have, more than any others, become the quintessence of Impressionism. It was there, too, that Monet acquired his studio boat, in which he made painting-trips up and down the river. His paintings of the area show, from all points of view and in all weathers, the stretch of the Seine which passes Argenteuil, and many parts of the surrounding countryside; sometimes the scene is rural, often the river is alive with sailing boats, and sometimes the view is backed by the factory chimneys which were then encroaching on the place (Plates 12, 15, 16, 17 and 20). Monet continued, on occasion, to include in his paintings the specifically modern, industrialized aspects of Paris and its surroundings until the later 1870s, and this interest culminated in 1877 in a series of views of the Gare Saint-Lazare and its surroundings (Plate 22, for instance).

6

During the 1870s, Monet did not submit any paintings to the official Salon. In 1872-3, he had a ready outlet for his work in the dealer Paul Durand-Ruel, whom he had met in London, and from 1874 onwards he and his friends organized a sequence of group exhibitions, which aroused considerable opposition and controversy in the press, but did not succeed in winning for them the recognition they sought. Durand-Ruel's financial difficulties later in the decade, combined with the commercial failure of their exhibitions, meant that Monet (never the best financial organizer) was often short of money, and was forced to plead for help from a few faithful friends and collectors.

Monet used the group exhibitions to mirror the variety of his work; he generally included one or more large paintings (for instance, *Luncheon*, Plate 5, rejected at the 1870 Salon, was included in the first show in 1874), and otherwise showed a selection of his smaller pictures – mainly outdoor scenes. These smaller paintings – rarely more than thirty inches across – formed the bulk of his work in the 1870s, and most of them must have been largely painted out of doors. Paintings of this sort were not considered important enough for the Salon, and, by including them in their own shows, the Impressionists were in effect creating a new form for the exhibition painting – tacitly declaring that it could be a more spontaneous and less elaborate expression of the painter's response to his subjects, and that an outdoor study could be suitable for exhibition. However, even these smaller paintings vary considerably in finish and in the way they convey their subjects; in the first show, for instance, Monet included a comparatively elaborate view of the Boulevard des Capucines alongside a very lightly worked painting, the notorious *Impression, Sunrise* (Plate 14), whose title led a critic, Louis Leroy, to christen the painters 'Impressionists'. Monet later said that he had called this painting an 'impression' because it could not pass as a view of the place; this use of the term 'impression' had been standard in art criticism over the past decade, to describe quick notations of atmospheric effects. In some later exhibitions, too, Monet juxtaposed such very summary works (often subtitled 'impression' or 'sketch') with other more highly finished versions of similar subjects. In a sense, these juxtapositions reflect a basic paradox in his ideas about his own painting – when working out of doors, he was tremendously proud if he could capture an effect in a quick and spontaneous sketch, but, as he grew older, he came increasingly to value the qualities which he could give to a painting by working at it over a period of time.

During the 1870s, Monet's colour became brighter, and he depended less on contrasts of dark and light tones to suggest light and shade; in open sunlit scenes (Plates 16, 17, 19, 20), he used luminous blues for the shadows in grass and trees, and expressed the fall of sunlight by treating the greenery in gradations of colour, from blue through various nuances of green to light yellow-greens and yellows in the highlights. It was by this subdivision and modulation of colours, which they used to express forms and space, that the Impressionists found a way of avoiding traditional chiaroscuro modelling (by gradations from dark to light tones). However, Monet did not at once use these new methods in all his paintings; in a sunlit autumn effect in 1873 (Plate 15), he could reduce the whole surface to a network of nuances and contrasts of clear light colour, but his more overcast scenes remain much more tonal in treatment (Plate 22), though gradually he introduced soft colour-variations into all areas even in these more subdued effects.

At the same time, Monet was changing the way he used brushstrokes to convey the subjects in his paintings. In *The Riverside Walk at Argenteuil* of 1872 (Plate 12), he varied his touch according to the different objects in the scene, but was willing to leave considerable areas quite smooth, with few variations of texture; by contrast, later in the decade he

7

began to variegate the whole surfaces of his paintings with small touches of paint, which are still based closely on the actual features of the subject, but are drawn into an overall mobile surface (Plate 17, for instance). Comparison of two figure-paintings, one of about 1868-9, the other of 1875, reveal this change (Plates 18 and 19); *The Red Cape* still echoes Manet's handling, with broad simple zones of paint set off by decisive individual dabs and dashes with the brush; in *Woman with a Parasol*, the natural forms of grass, figures, and sky become part of a much more continuous broken rhythm, which is augmented by the relationships of clear, varied colours. It was the handling and colour of paintings such as this which seemed so revolutionary and unintelligible to the public of the 1870s.

The course of Monet's life changed markedly in 1878. He left the Paris area and moved to Vétheuil, a secluded village further down the Seine, partly because life was cheaper there, but also, one suspects, because the continued commercial failure of the group exhibitions had left him disillusioned about the prospects offered by any collective activities. With him he took his wife (now sick) and children, and the wife and children of his former patron, the now ruined financier Ernest Hoschedé. Monet's wife died in 1879, and Hoschedé became increasingly estranged from his family; this led Monet's ménage with Alice Hoschedé to become a permanent arrangement, finally formalized by their marriage in 1892, after Hoschedé's death. Monet's break with the Impressionist group was highlighted in 1880 when, instead of showing at that year's Impressionist exhibition, he submitted to the official Salon, sending two large paintings executed in the studio from smaller outdoor studies; the more conventional one, a summer scene (Plate 26), was accepted but badly hung, while the other, a dramatic canvas of ice-floes (Plate 27), was rejected. Never again did he send a painting to the Salon, but thereafter generally exhibited in one-man shows organized by dealers. In 1881, Monet attained a comparative financial security, when Durand-Ruel started again to buy his work regularly, but true commercial success only arrived in 1889, when collectors in the United States took him up in earnest.

While at Vétheuil, Monet restricted his subjects to the village and the hamlet of Lavacourt which faces it across the Seine, and the banks of the river. Many subjects he painted on more than one occasion (Plates 24 and 25), trying to capture the aspects of the area in all seasons and weathers – spring, summer, the sun coming through the morning fog (Plate 24), and the effects of ice in the remarkable winter of 1879-80 (Plate 27). His letters show that these desolate winter landscapes helped him to recapture his faith in painting after the death of his wife; his portrayals of this natural drama allowed him to overcome his grief. His views of the Vétheuil area are generally simple and horizontal in emphasis, often seen frontally across the river; they depend for their variety on the endless changes of foliage, weather, and lighting. At this period, too, he painted his most significant group of still-lifes – bouquets of flowers and arrangements of fruit (Plate 23), all disposed across the canvas with a freedom and informality that was to influence Van Gogh deeply. In 1883, Monet moved his base to Giverny, a little village rather further down the Seine valley, where he was to live for the rest of his life. Here he chose motifs similar to those at Vétheuil, often deliberately anti-picturesque in effect, of simple meadows, orchards, bands of hills, and banks of trees, enlivening these deceptively simple subjects by delicate variations of colour and brushwork (Plate 32).

However, the bulk of Monet's work during the 1880s was done on a long series of journeys, initially to the coastal resorts of Normandy such as Fécamp, Etretat and the area

round Dieppe (Plates 28 and 29), and later to the Mediterranean coast (Plates 30, 33 and 34), to the island of Belle-Isle off Brittany (Plate 31), and to the valley of the Creuse in the Massif Central (Plate 35). In his paintings from these journeys, he concentrated on the most dramatic aspects of each location – the unexpected vistas from the tops of the Dieppe cliffs, the vast rock-arches at Etretat, the lavish colour and vegetation of the Riviera, the waves beating on the granite rocks of Belle-Isle. Taking up again the challenge set him by the ice-floes at Vétheuil in 1879-80, Monet went on exploring themes of elemental oppositions and extremes of weather and lighting. He consciously wanted to extend the range of his own painting, to prove that no natural effect was too transitory or too powerful to be captured by a determined outdoor painter; the descriptions which have come down to us of his working methods at this period show that at times he deliberately courted the most hostile weather conditions. On one occasion at Etretat, he was swamped by a vast wave, when he had mistimed a session of painting on the beach after misreading the tide tables; in the gales on Belle-Isle, his easel had to be tied to the rocks; in snow and ice his beard grew icicles, and he had himself fastened to the ice, with a hot-water bottle to keep his hands warm enough for him to paint.

Monet intended his groups of paintings of different sites each to have some dominant mood, and played off one group against another. On occasions, he went to great lengths to preserve such a mood. In 1889, he meant his paintings of the Creuse (Plate 35) to be of stark winter effects, in contrast to the lightness and delicacy of the Antibes views of the previous year (Plates 33 and 34). However, his work in the Creuse was delayed by rain, and spring buds started to grow on a great oak tree which he was painting; rather than lose his winter effect, he employed workmen to strip off buds before he would finish his picture, so important was his preconception of the type of effect he wanted to paint.

To convey the extreme effects he had chosen to tackle, Monet had to find pictorial equivalents for the forms he saw before him. The act of composition, for an outdoor landscape painter, involves choosing a viewpoint and deciding how the edges of the canvas are going to cut the scene before him. In his coastal scenes, Monet favoured views from the clifftops, with a heavy cliff mass on one side set against the wide expanses of the sea, and, sometimes, the sinuous lines of silhouetted trees (Plates 28, 29, 31 and 33); this led him to dispose his forms in ways very like Japanese landscape prints, of which he was an avid collector. These prints must have helped him to find the compositional patterns which would best convey the characteristics of such scenes. For Monet, the art of Japan was a form of naturalism, which helped revitalize his way of seeing his own surroundings; he did not seek the philosophical meaning that Van Gogh found in it, nor did he use it as a sanction for stylized decorative arabesques, as did Gauguin and the Art Nouveau artists.

At the same time, dramatic sunsets, such as that in *Varengeville Church* (Plate 29), forced him to find a way of translating into paint the most lavish of natural colour-schemes, and he responded by keying up his colour to greater intensity, and by emphasizing the contrasts between complementary colours – oranges and reds set against blues and greens. The problem of suggesting in a painting the full luminosity of sunlight was highlighted by his experiences on the Mediterranean coast. His letters from the South harp on the difficulty of adjusting his palette to the conditions, and on the pervading blue and rose colours of the atmosphere; to convey this, he adopted a pale pastelly colour-range with accents of hot colour, and emphasized this blue-rose contrast, giving his southern paintings carefully integrated colour-schemes (Plates 30, 33 and 34). Monet, by his own

experiences of painting, had discovered the truth of the maxim uttered many years later by his friend Paul Cézanne (1839-1906): 'I was very pleased with myself when I discovered that sunlight cannot be *reproduced*, but that it must be *represented* by something else – by colour.' *Varengeville Church*, predating Monet's southern trips, shows that these experiments did not begin with his Mediterranean work, and we find, in his later northern paintings, an increasing emphasis on carefully coordinated colour harmonies as a means of suggesting atmospheric effects; this reaches its height in his series of Haystacks and of Rouen Cathedral in the early 1890s (Plates 38-41).

Monet also adapted his brushwork to the demands of his new range of subjects – particularly the palm-trees of Bordighera (Plate 30), and the stormy waves of Channel and Atlantic (Plate 31). He used the brush in an almost calligraphic way, suggesting the movements of the forms in front of him with long flowing curls and ribbons of paint; this handling creates an emphatic pattern on the canvas, since the brush-strokes remain clearly visible as such. Paint-surfaces of this sort, with Monet's more unified colour-schemes of the period, help to make his pictures far more decorative in their overall effect than his characteristic paintings of the High Impressionist phase of the 1870s; but at the same time these paintings still convey a strong sense of the actual forms, colours, and space of the scene which Monet had before him.

This growing emphasis on two-dimensional qualities in Monet's paintings of the 1880s corresponds to a gradual change in his working methods. Outdoor painting remained essential to him as the starting point for his pictures, and he still valued highly the ability to suggest quickly and directly the effect of a scene; but he began to feel the need to look over every painting back home in the quiet of his studio, and to retouch it at his leisure. His dealers found that it took longer to prise his latest paintings from him, and from his letters it is clear that many of the paintings from his travels reached home in quite a rough state and needed considerable reworking to make them saleable, particularly since Durand-Ruel was urging Monet not to part with inadequately finished paintings. His retouching seems to have taken various forms – re-emphasizing features not clearly enough defined, heightening the colours of a scene, sharpening the contrasts between different elements within the painting, and finally adding touches that would knit together the colour relationships and inflexions of brushwork into a single harmonious pattern; he also began to sign his pictures in colours that harmonized with their colour-schemes. His studio reworking was not in conflict with the initial, outdoor stages of the painting, which must normally have established the main elements of the picture; but it accentuated, on the paint-surface, the relationships which the motif had suggested. In *Varengeville Church* (Plate 29), the red strokes on the hillside by the left margin, which lead the eye down from the sunset and across to the foreground bushes, are examples of the sort of accents which Monet is likely to have added in the studio; in paintings of the 1890s, such as the series of Haystacks and Rouen Cathedral, the rich colour-schemes seem to have been considerably elaborated away from the motif.

During his period of restiveness in the 1880s, Monet flirted for the last time, in the later part of the decade, with the idea of becoming a figure-painter. Following the advice of friends, among them Renoir (who was at the time turning back to the nude and to traditional methods), he began to paint figures in the fields around Giverny (Plate 36), and compositions of girls in boats on local streams, using as models his and Alice Hoschedé's children, since she threatened to walk out on him if he employed a

professional model. However, he seems to have found it difficult to apply to the figure his ways of treating landscape, and after 1890 figures almost wholly disappear from his paintings.

In 1890, there was a sudden change in Monet's patterns of work. He stopped travelling, and focused instead on a series of paintings of a single subject – of one or two haystacks variously grouped in a field by his house (Plates 38 and 40). Fifteen of these he exhibited together the following spring, and they were followed by other equally unified series – Poplars in 1891–2 (Plate 37), Rouen Cathedral in 1892–4 (Plate 41), and many others; this became Monet's standard way of working for the rest of his life. His new-found financial security may well have been the catalyst which allowed him to embark on these experiments at this stage of his career; freed from the pressures of being his own salesman, he could now concentrate on a single pictorial problem for a considerable period.

In some ways, the series continue tendencies in his previous painting, but in others they take a quite new direction. Since the 1860s, Monet had, on occasion, painted more than one canvas of a single subject under different conditions (Plates 24 and 25, of 1879, are an example), and, during the 1880s, he sometimes painted the same motif six or more times (for instance, the Pyramides at Port-Coton on Belle-Isle, Plate 31), moving on to a different canvas when the light-effect in front of him changed. But he did not, at that stage, treat these groups of paintings as separate units, and in his exhibitions he tended to emphasize the variety of motifs which he had treated at any location, rather than including several versions of a single subject, since he continued to treat exhibitions as a shop-window for the full range of his work. He had in a sense presaged the idea of exhibiting such groups together at the Impressionist exhibition of 1877, by including eight views of the Gare Saint-Lazare and its surroundings (including Plate 22); but these were very varied in viewpoint and composition, and were only one of the many aspects of Monet's art seen at this exhibition. In the Haystacks of 1890-1 and in his later series, Monet was creating a unity which could only be properly appreciated when they were first exhibited and all could be seen together, since, as Monet told a visitor to the Haystacks show, the individual paintings 'only acquire their value by the comparison and the succession of the entire series'. The exhibition itself, rather than just the paintings which made it up, had now become the work of art. Only at the Jeu de Paume in Paris, which houses five of the Rouen Cathedral series, can we begin to appreciate this effect today.

In their subjects, too, the early series, notably the Haystacks and the Poplars, are quite unlike Monet's previous work. They wholly lack topographical interest, and tell us nothing about the area in which Monet was painting; even the Rouen Cathedral paintings, once one has seen one of them, have nothing more to tell us about the architecture of the façade. Instead, the emphasis is on atmospheric variations, on the way in which every successive light-effect modifies and transforms the appearance of the forms. Monet wrote in 1890 that in the Haystack paintings he was trying to capture '"instantaneity", above all the enveloping atmosphere, the same light diffused over everything', and commented the next year: 'For me, a landscape does not exist in its own right, since its appearance changes at every moment; but the surrounding atmosphere brings it to life – the air and the light, which vary continually. For me, it is only the surrounding atmosphere which gives subjects their true value.' This concentration on almost tangible effects of atmosphere takes up a theme which had fascinated him for

twenty years – since he had painted the Thames in 1870-1 (Plate 9); his most celebrated single picture, *Impression, Sunrise* (Plate 14), had treated this theme, as had *Vétheuil in the Fog* (Plate 24), a painting he had exhibited on several occasions in the 1880s as a symbol of the ephemeral effects he was trying to record. Mist effects are predominant in most of his series of the 1890s, and it was the winter mists and fogs of London which led him back to paint there in 1899-1901 (Plate 43), as he told René Gimpel: 'I like London only in the winter; without the fog, London would not be a beautiful city. It is the fog which gives it its marvellous breadth. Its regular, massive blocks become grandiose in this mysterious cloak.'

Monet's earlier paintings of mists were just isolated canvases, quickly painted; in the series of the 1890s, he found a way of making something more permanent out of these most transitory effects. He told a friend at the time that he had become dissatisfied with painting 'anything that pleased him, no matter how transitory'; instead, he had to 'keep at a thing for a certain space of time', and was seeking 'more serious qualities' in his pictures. He pursued this by following further the direction which his working methods had taken in the 1880s – reworking his paintings over a longer period in the studio, and emphasizing their harmonious colour-schemes. He still began virtually all his canvases in front of the subject, but was painting effects so ephemeral that he had little chance to work them fully on the spot; back in his studio, he elaborated and enriched them, often reworking one canvas by comparison with others in the same series, until some of his paintings, such as those of Rouen Cathedral (Plate 41), are far from any immediate perceptual experience of the building, but instead suggest, by the subtlety of their colour harmonies, the transforming qualities of sun in mist. It is not surprising to find that Monet's admiration for Turner was at its height at this period. These paintings are far from the fresh, coloured notations which had given Impressionism its reputation in the 1870s; they create a suggestive, evocative atmosphere which has much in common with the symbolism of Monet's friend, the poet Mallarmé.

In the early 1890s, Monet began to build himself a water-garden at his home in Giverny, making a pond by diverting a stream, and building a bridge over it; initially, he had no thought of painting the garden, but he soon came to see its pictorial possibilities. In the first series, of the pond and bridge (Plates 44 and 45), flowers, overhanging trees and bridge surround the water and its lily-pads. After 1900, Monet enlarged the pond, and embarked on a series, only exhibited in 1909, in which the banks of the pond are first pushed to the top of the canvas, and then disappear altogether; the whole picture is given over to the surface of the water, with lily-pads set off against reflections of trees, clouds, and sky.

Monet had since the late 1890s cherished the idea of transforming his paintings of the lily-pond into a single decorative scheme, which would run continuously round a room. Only in 1914 did his friend the politician Clemenceau persuade him that it was not too late to start work on such a project, and Monet began in 1916, in a vast studio built for the purpose, to paint a succession of huge canvases, two metres high, of the water surface, working from memory and from smaller studies made by the pond. Near the end of his life, he selected some of these for installation in two oval rooms in the Orangerie in Paris, where they remain, presented as Monet had planned. The large paintings not selected for the Orangerie emerged from Monet's studio during the 1950s, and can be appreciated in photographs more easily than the ensembles in the Orangerie; but these too are handled

on a scale and with a freedom which can only be sensed from the paintings themselves (Plates 46 and 47; detail Plate 48).

In these water-surfaces, Monet had chosen a subject still more ephemeral, if this is possible, than the mists of the series of the 1890s; late in his life, he told an interviewer what he was seeking: 'The water-flowers themselves are far from being the whole scene; really, they are just the accompaniment. The essence of the motif is the mirror of water, whose appearance alters at every moment, thanks to the patches of sky which are reflected in it, and which give it its light and movement. The passing cloud, the freshening breeze, the light growing dim and then bright again, so many factors, undetectable to the uninitiated eye, transform the colouring and distort the plane of the water. One needs to have five or six canvases that one is working on at the same time, and to pass from one to the next, and hastily back to the first as soon as the original, interrupted effect has returned.'

The water-lily decorations dispense almost completely with the conventional ingredients of painting. They have no clear compositional focus; as on the pond itself, the lily-pads float freely across the whole breadth of the canvases, which seem as if they could be continued indefinitely beyond their side margins. This sense of continuity across their surfaces is increased by their very homogeneous colour-schemes – generally light in tonality, and mostly within a narrow range of colour, in variations of greens and blues, with yellows and mauves. Their brushwork explores further the free calligraphy which Monet had used in the 1880s to describe lavish foliage and stormy seas. When one moves close to these canvases, the individual strokes of paint sweep boldly across their surface, without being firmly tied to the forms which they suggest, and the colour-nuances give a rainbow-like pigmentation to the skin of the painting (see detail, Plate 48); at a distance, the colour and brushwork coalesce into broad harmonies and rhythms, drawing the whole activity of the paintings up on to the picture-plane, but, as one contemplates it, this surface becomes the broad surface of the pond which is the paintings' subject.

Monet's devotion to nature and the lyrical handling of the water-lily canvases seemed outmoded to younger artists in the 1920s and 1930s; but the implications of these open-structured paint-surfaces have since 1945 been fully explored by the Abstract Expressionist painters in the United States, and their experiments have led artists and critics to a reassessment of Monet's whole *oeuvre*. However, Monet remained essentially of his own time. Like Cézanne (the prophet of much of the formalist abstraction of the earlier years of the twentieth century), Monet throughout his career sought ways of conveying his sensations of nature. But, within this broad framework, he extended the vocabulary of naturalism in painting, by freeing colour, brushwork, and composition from many outworn conventions, and using them to create a new sort of pictorial coherence. In Monet's paintings, the harmonies and rhythms of colour and brushwork become the equivalent of the unifying effects of light and atmosphere in nature.

Select Bibliography

Rewald, J., *The History of Impressionism*, 4th edition, London and New York, 1973 (with extensive critical bibliography of Monet).

Geffroy, G., *Claude Monet, sa vie, son temps, son oeuvre*, Paris, 1922.

Wildenstein, D., *Monet, vie et oeuvre*, vol. I (1840–81), Lausanne and Paris, 1974 (catalogue raisonné, with full biography).

Seitz, W.C., *Claude Monet, seasons and moments*, catalogue of exhibition at Museum of Modern Art, New York, 1960. *Monet*, London and New York, 1960.

Cooper, D. and Richardson, J., *Claude Monet*, a catalogue of exhibition, Edinburgh Festival and Arts Council of Great Britain, 1957.

Isaacson, J., *Monet: Le Déjeuner sur l'Herbe*, London, 1972.

Outline Biography

1840 Born in Paris, 14 November.

c. 1845 Family moves to Le Havre.

c. 1857 Meets Boudin, who introduces him to landscape painting.

1859-60 Stay in Paris; meets Pissarro.

1862 Meets Jongkind.

1862-4 In studio of Gleyre, where he meets Renoir, Bazille, Sisley.

1865 First exhibits at official Paris Salon; shows again in 1866 and 1868; rejected in 1867, 1869 and 1870.

1870 Marries Camille Doncieux.

1870-1 Visits London, then Holland, as refugee from Franco-Prussian War and Commune.

1871-8 Based in Argenteuil.

1874 Contributes to the first Impressionist exhibition; also shows in the exhibitions of 1876, 1877, 1879 and 1882.

1878-81 Lives at Vétheuil, with Alice Hoschedé and her children.

1879 Death of Monet's wife Camille.

1880 Exhibits for the last time at the official Salon.

1880-9 Decade of travels, to Normandy coast, Mediterranean, etc.

1883 Moves to Giverny, where he later builds his water-garden.

1889 Retrospective exhibition, at Petit's Gallery in Paris, wins great acclaim.

1891 Exhibition of his first true series, the Haystacks.

1892 Marries Alice Hoschedé.

1895 Exhibition of Rouen Cathedral series.

1899-1901 Visits London, to paint the Thames; exhibits his London series in 1904.

1900 First Lily-pond series exhibited.

1916 Begins to paint Water-lily decorations.

1926 Dies at Giverny, 6 December.

List of Plates

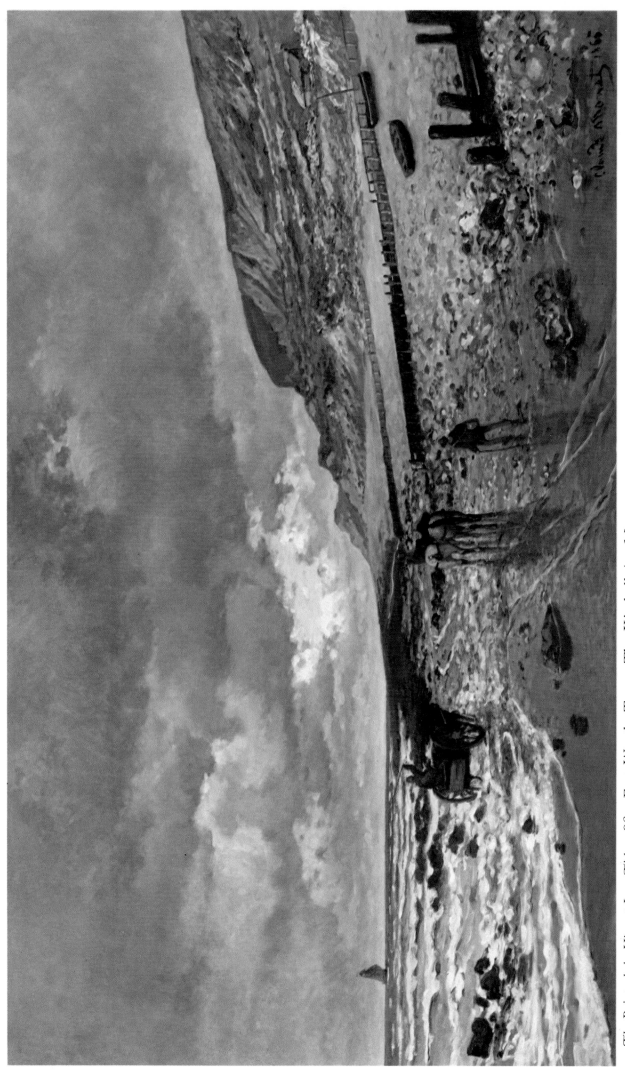

1. *The Pointe de la Hève at Low Tide.* 1865. Fort Worth, Texas, The Kimbell Art Museum.

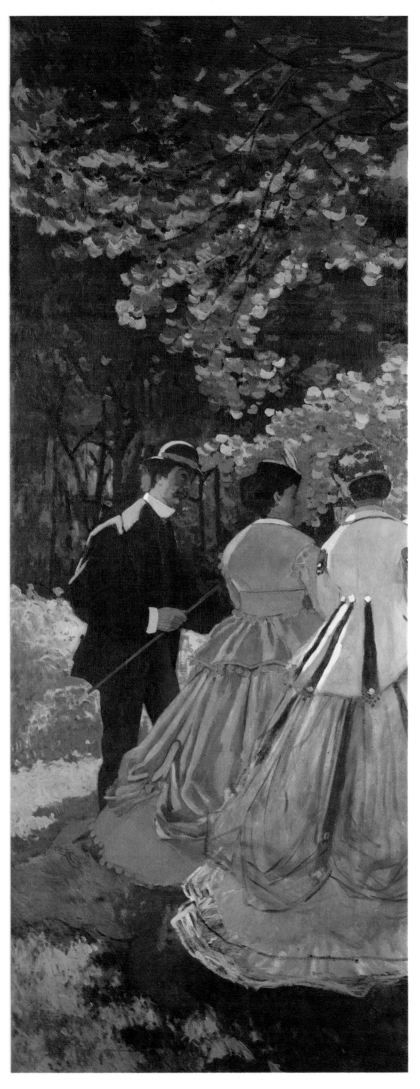

2. *Le Déjeuner sur l'Herbe* (fragment). 1865–6.
Paris, Louvre (Jeu de Paume).

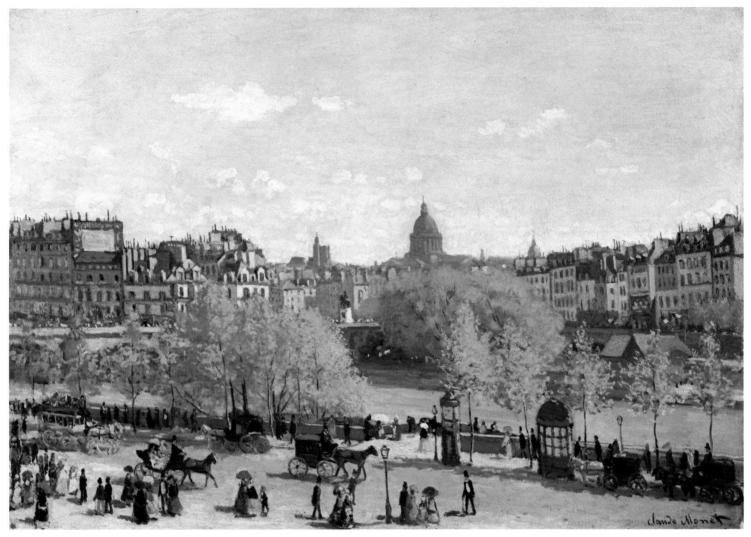

3. *The Quai du Louvre.* 1867. The Hague, Gemeentemuseum.

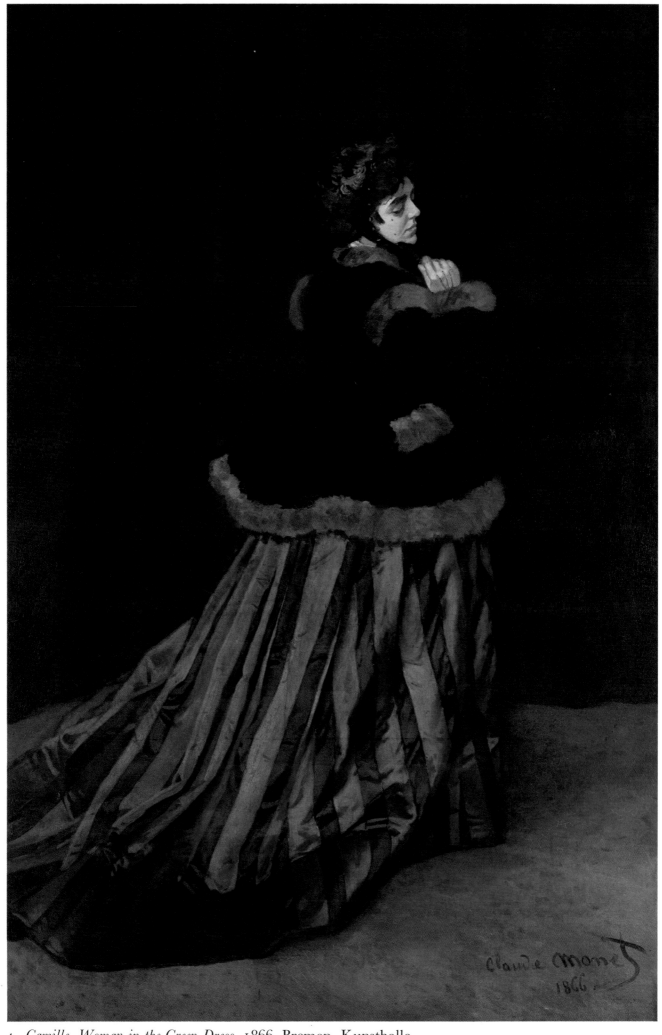

4. *Camille, Woman in the Green Dress*. 1866. Bremen, Kunsthalle.

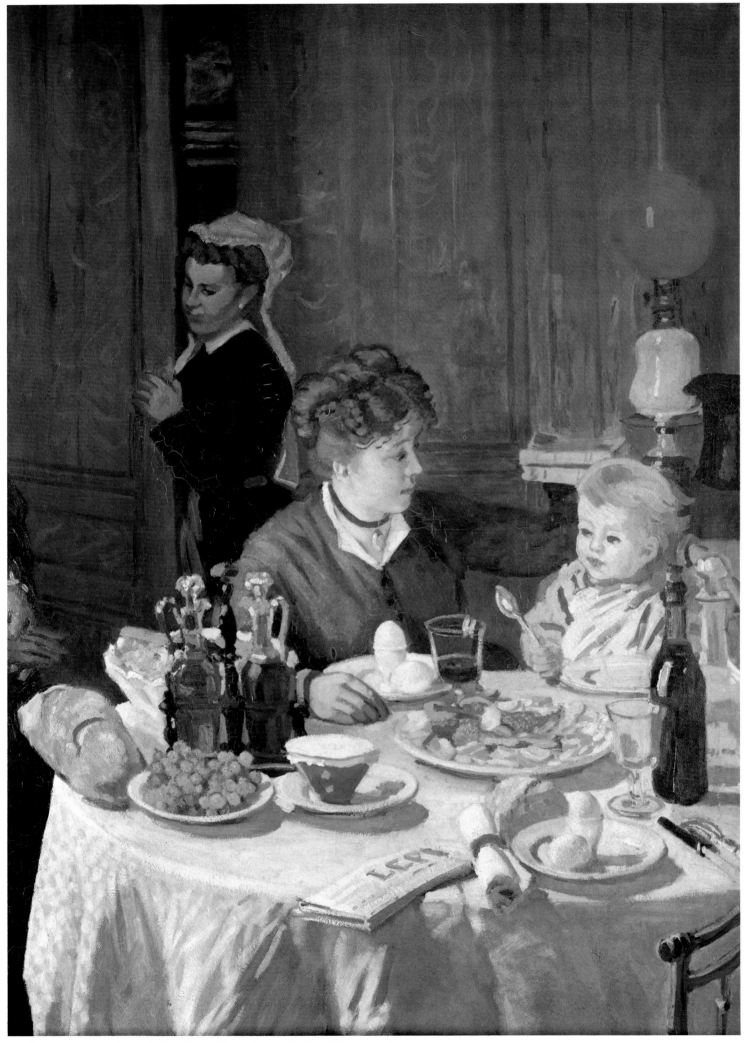

5. *Luncheon* (detail). 1868. Frankfurt, Städelsches Kunstinstitut.

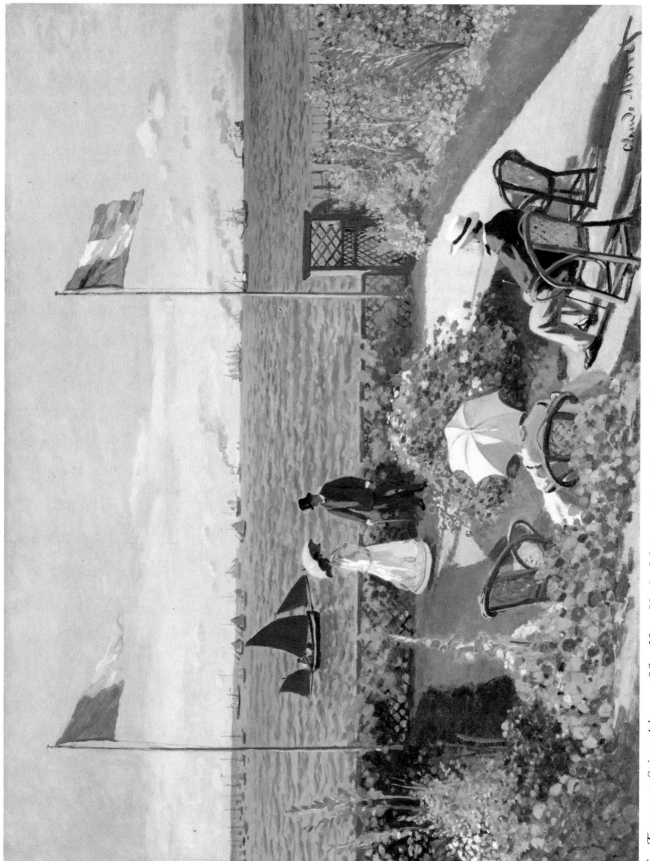

6. *Terrace at Sainte-Adresse.* 1867. New York, Metropolitan Museum of Art.

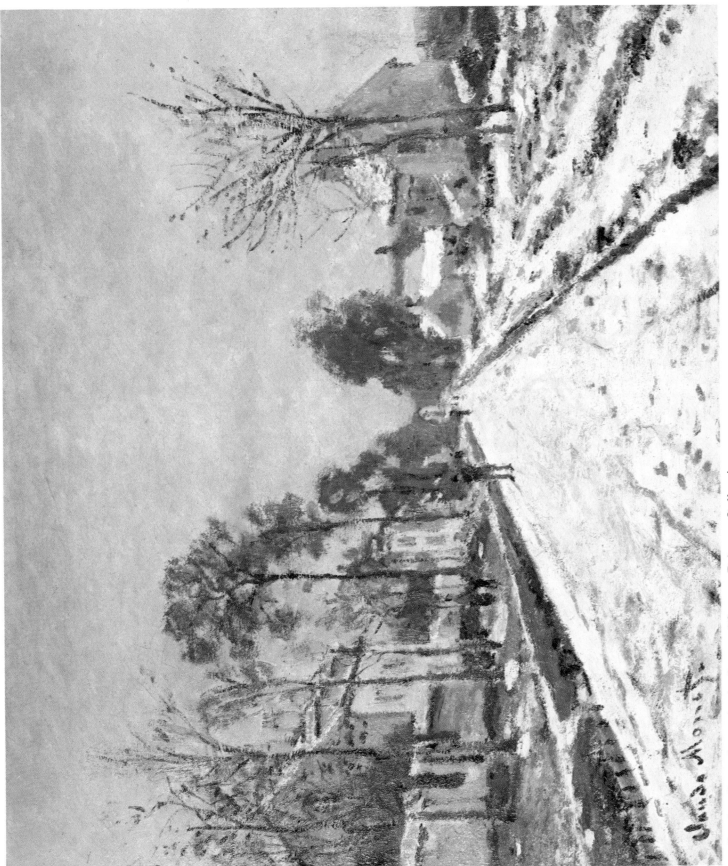

7. *Road at Louveciennes in the Snow.* 1869–70. Private Collection.

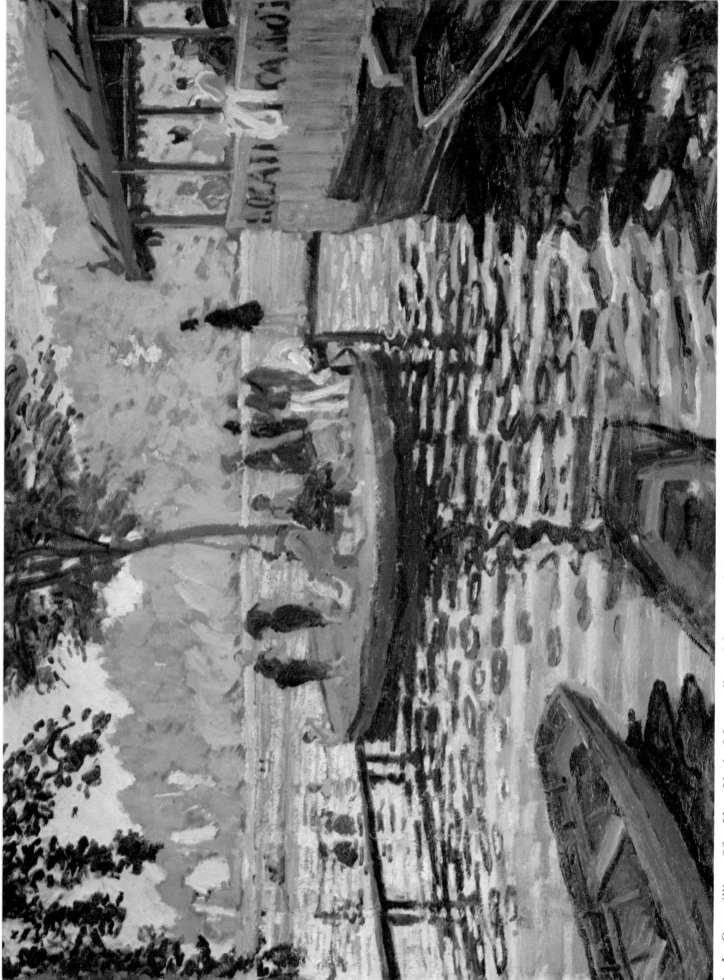

8. *La Grenouillère*. 1869. New York, Metropolitan Museum of Art.

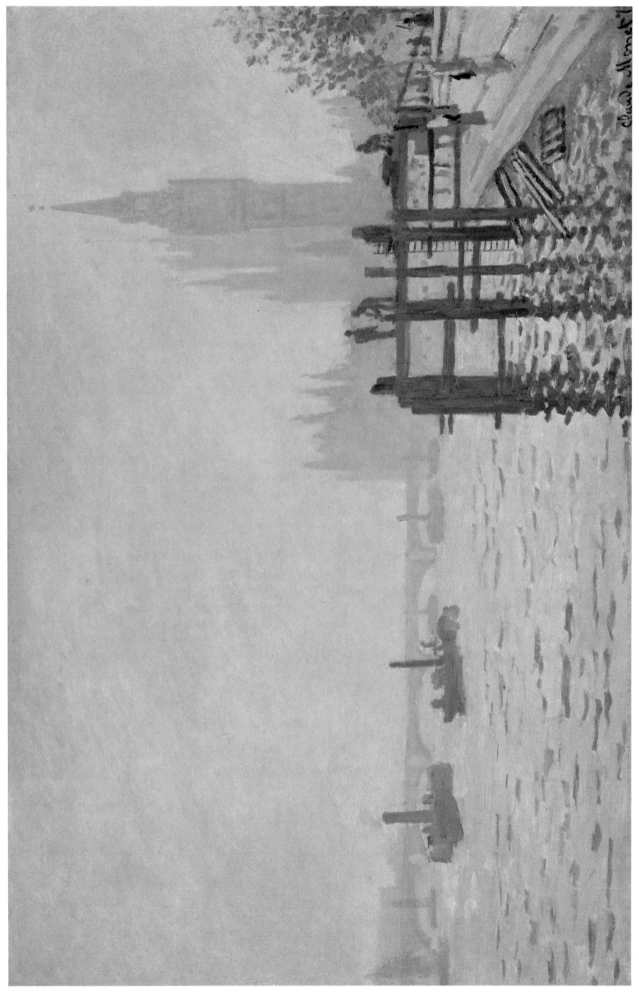

9. *The Thames and the Houses of Parliament.* 1870–1. London, National Gallery.

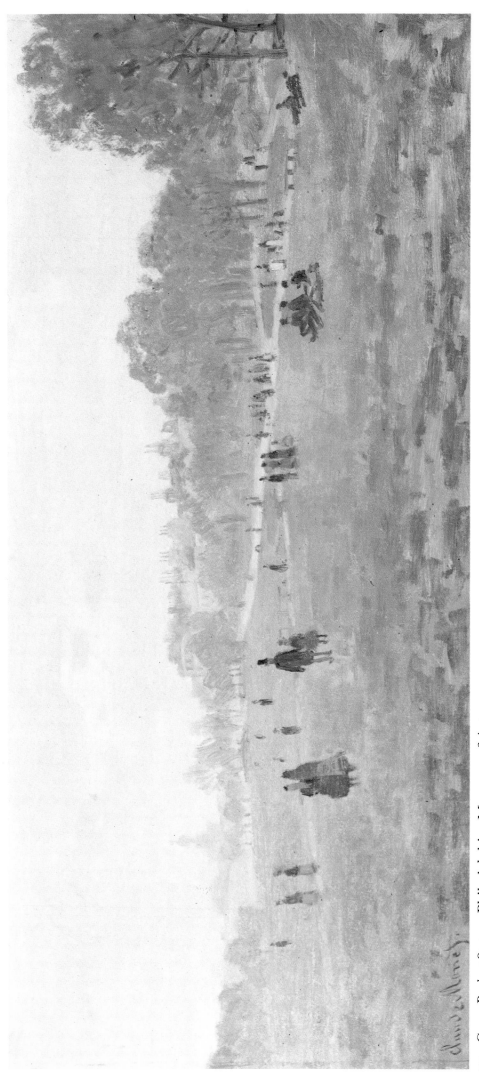

10. *Green Park.* 1870-1. Philadelphia, Museum of Art.

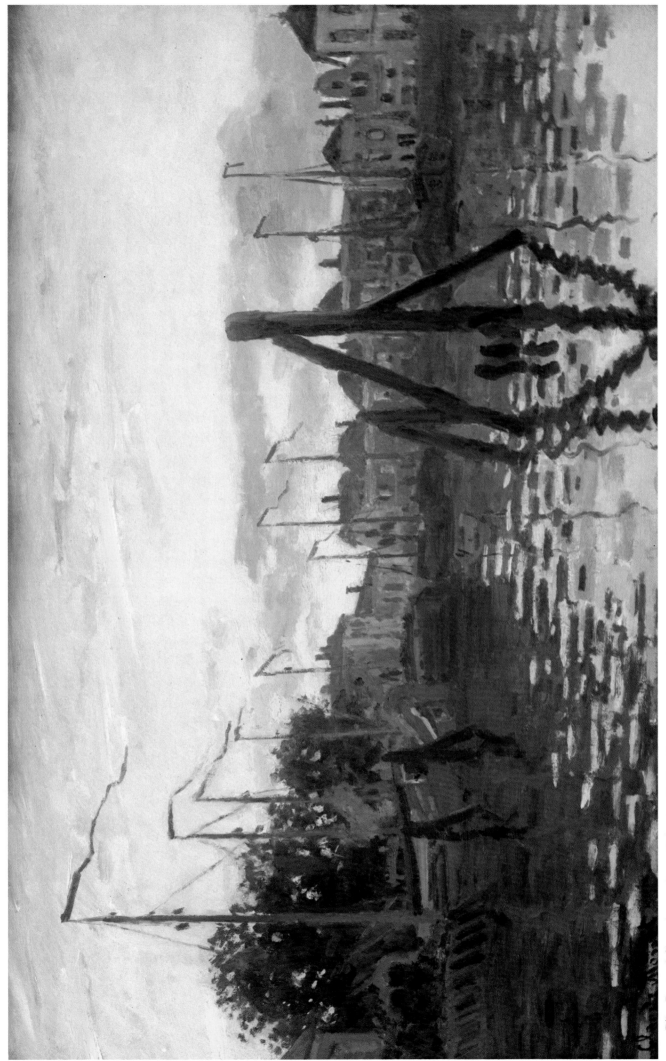

11. *The Port of Zaandam*. 1871. Private Collection.

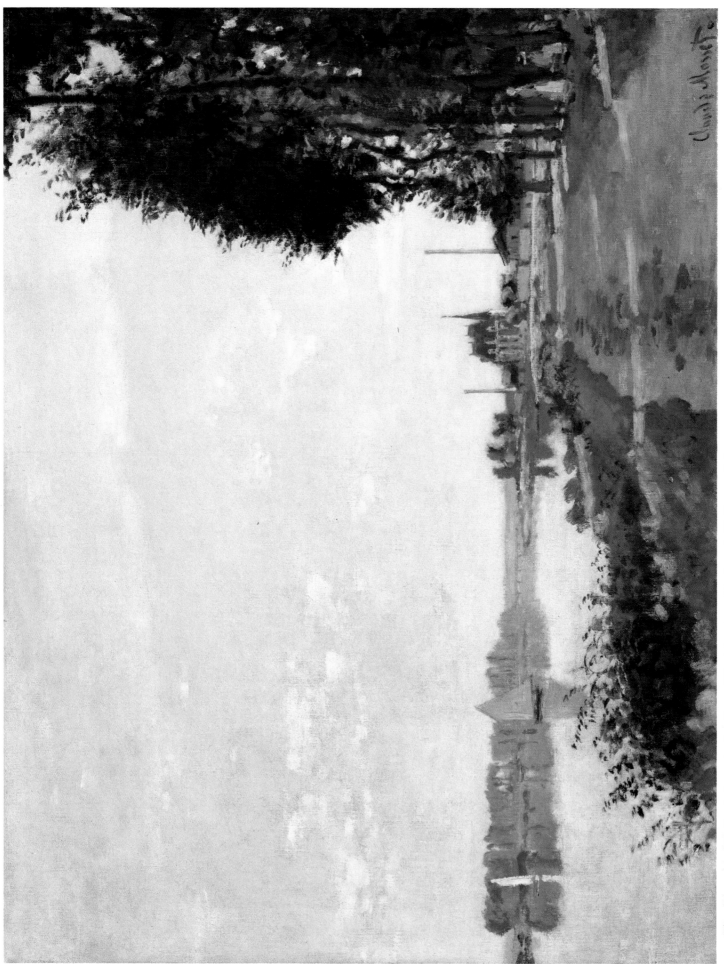

12. *The Riverside Walk at Argenteuil.* 1872. Washington, National Gallery of Art.

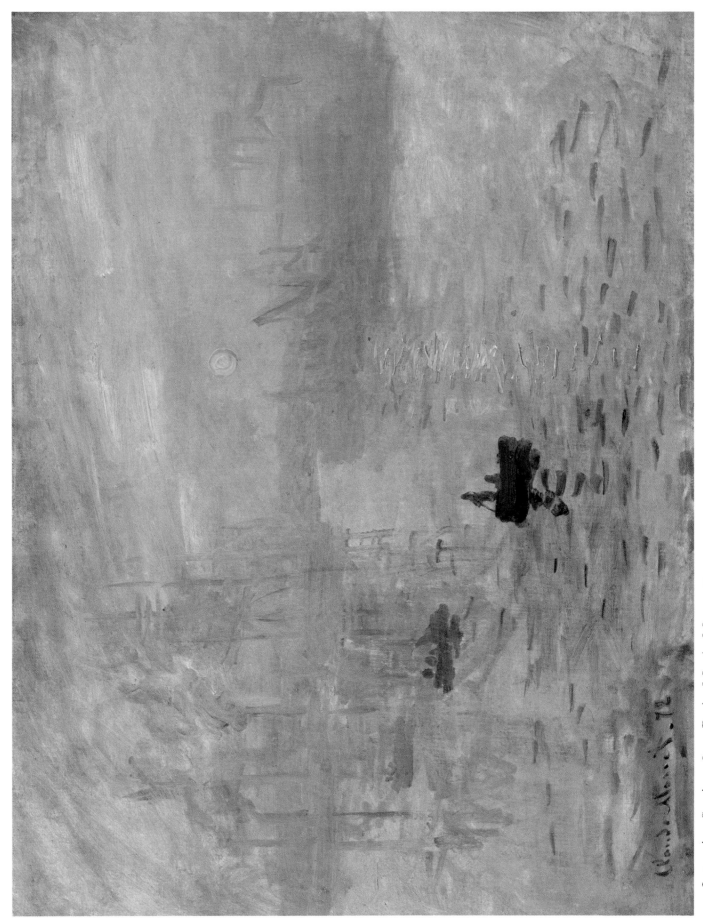

13. *Impression, Sunrise.* 1872. Paris, Musée Marmottan.

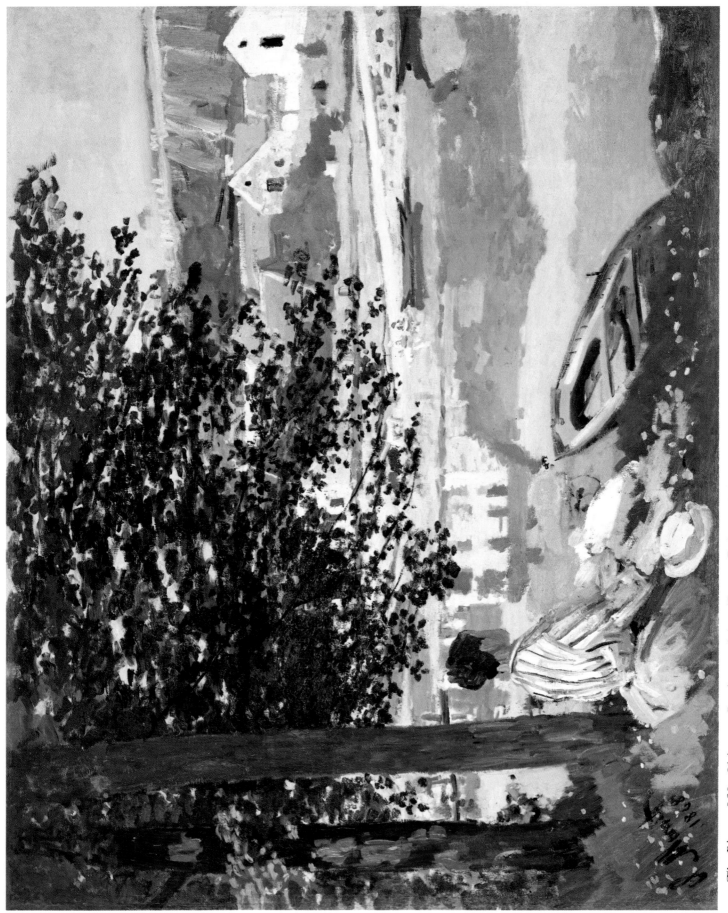

14. *The River.* 1868. Chicago, Institute of Art (Potter Palmer Collection).

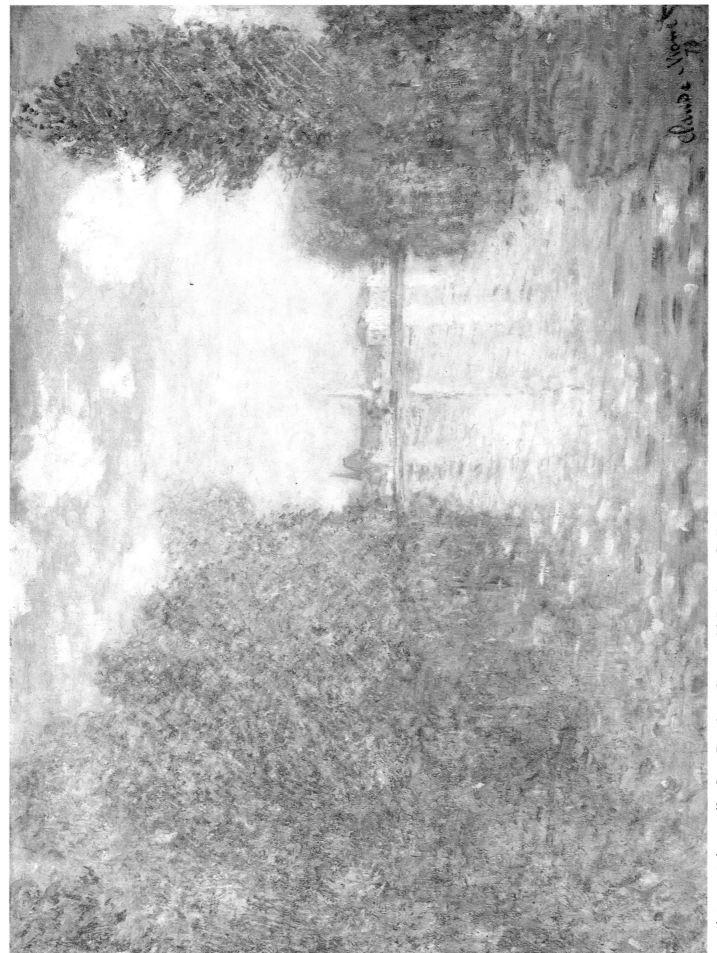

15. *Autumn at Argenteuil.* 1873. London, Courtauld Institute Galleries.

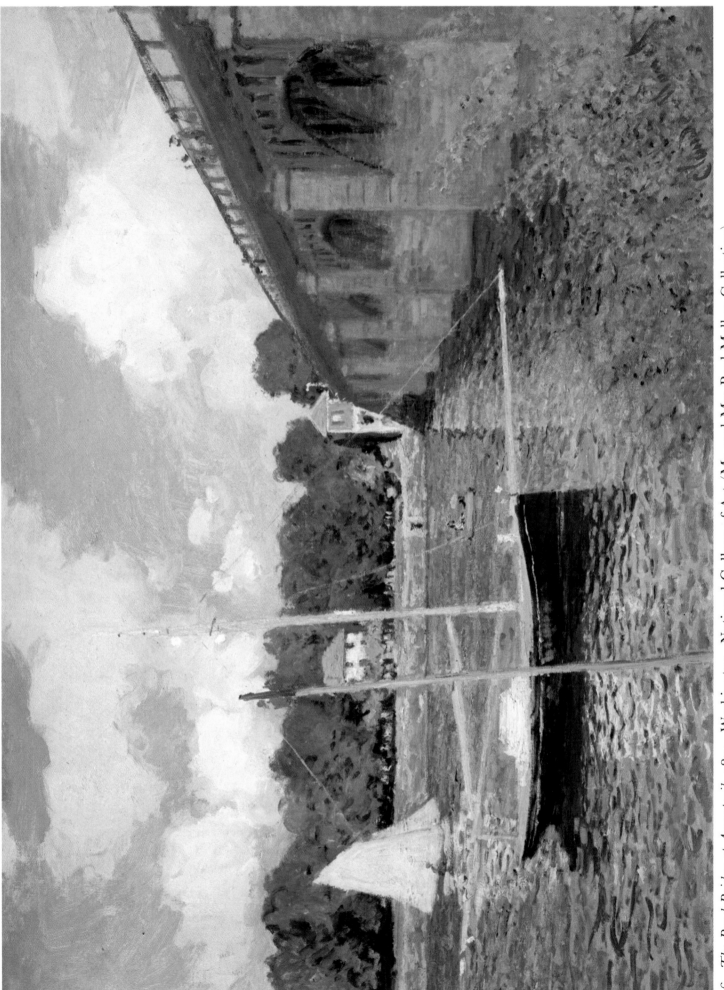

16. *The Road-Bridge at Argenteuil*. 1874. Washington, National Gallery of Art (Mr and Mrs Paul Mellon Collection).

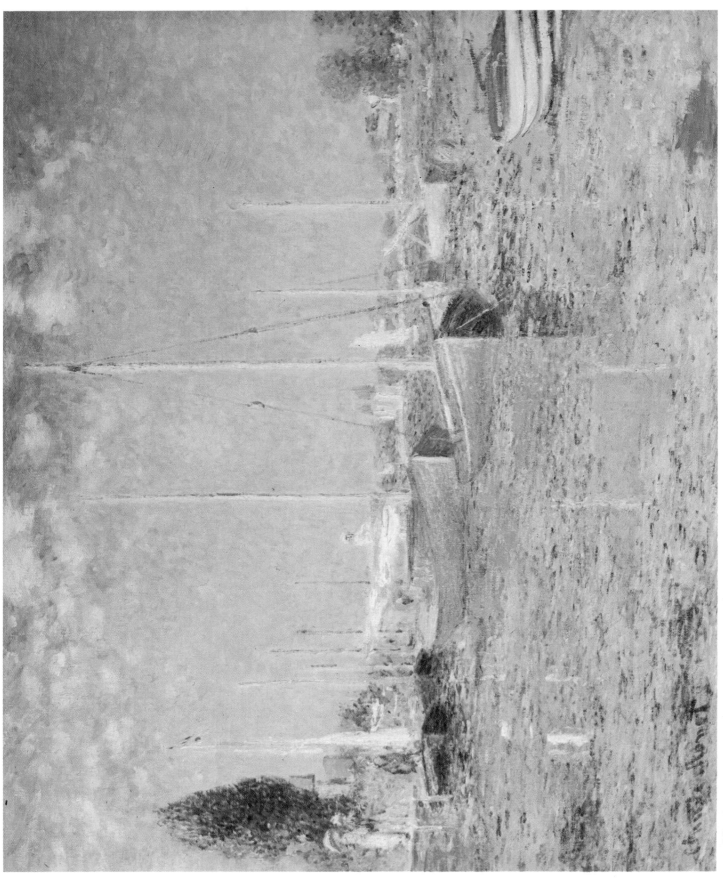

17. *The Red Boats, Argenteuil.* About 1875. Paris, Louvre (Jeu de Paume, Walter and Guillaume Collection).

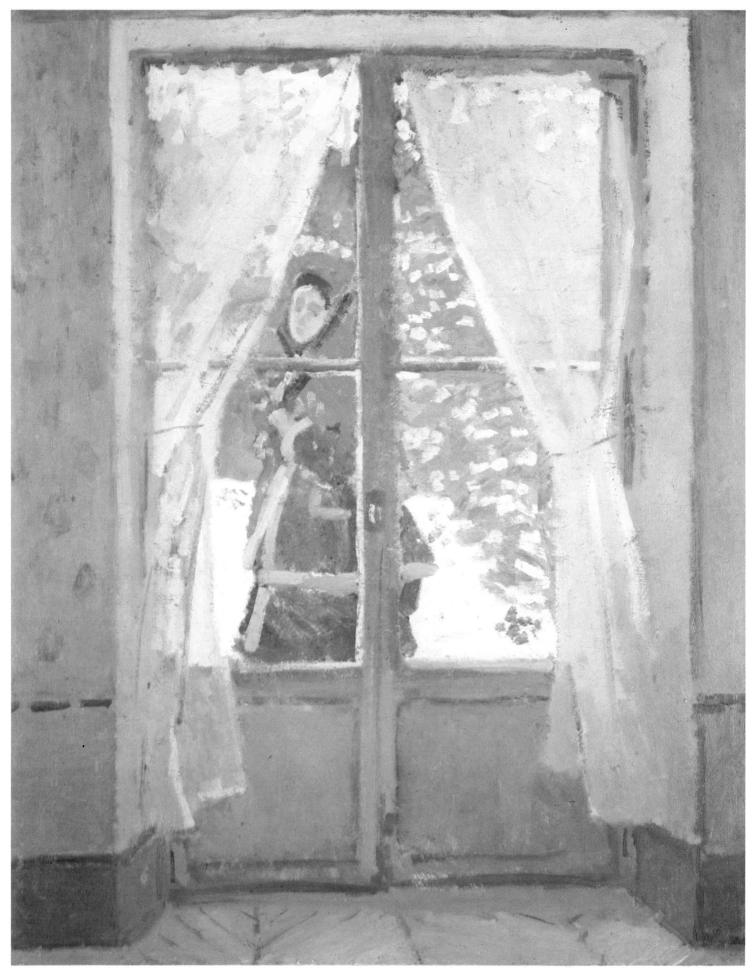

18. *The Red Cape*. About 1868-9. Cleveland, Museum of Art.

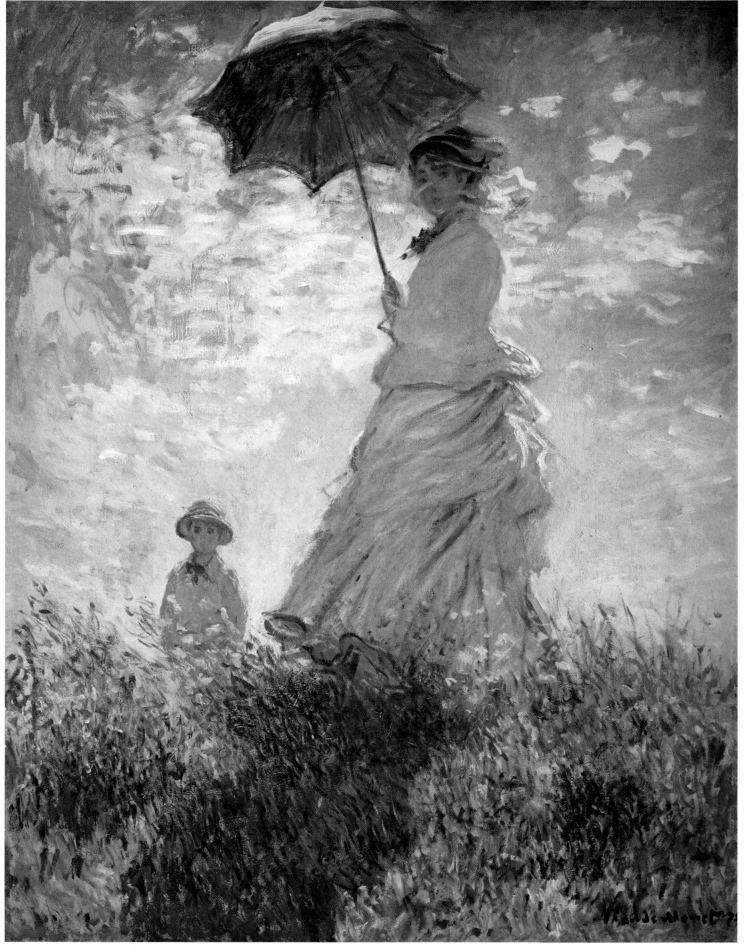

19. *The Promenade, Woman with a Parasol.* 1875. Washington, National Gallery of Art (Mr and Mrs Paul Mellon Collection).

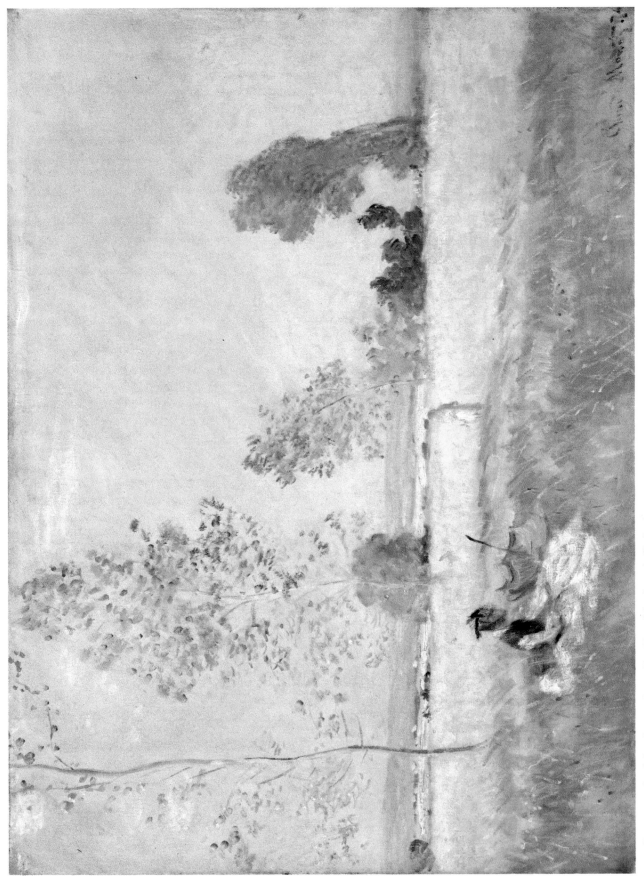

20. *Summer, the Meadow.* 1874. Berlin, National-Galerie.

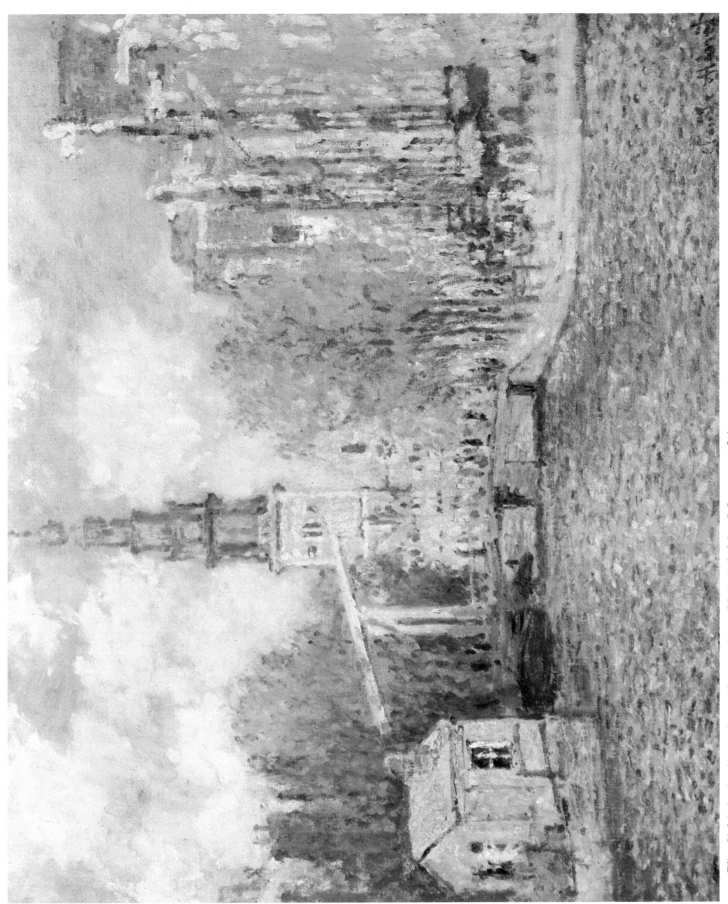

21. *The Zuiderkerk, Amsterdam.* About 1874. Philadelphia, Museum of Art.

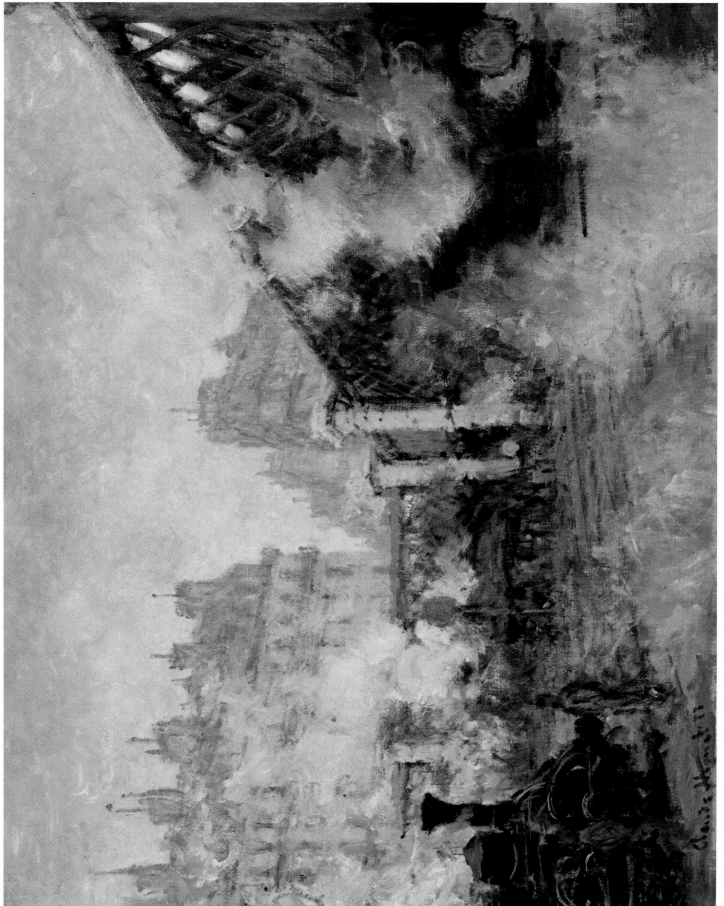

22. *The Pont de l'Europe.* 1877. Paris, Musée Marmottan.

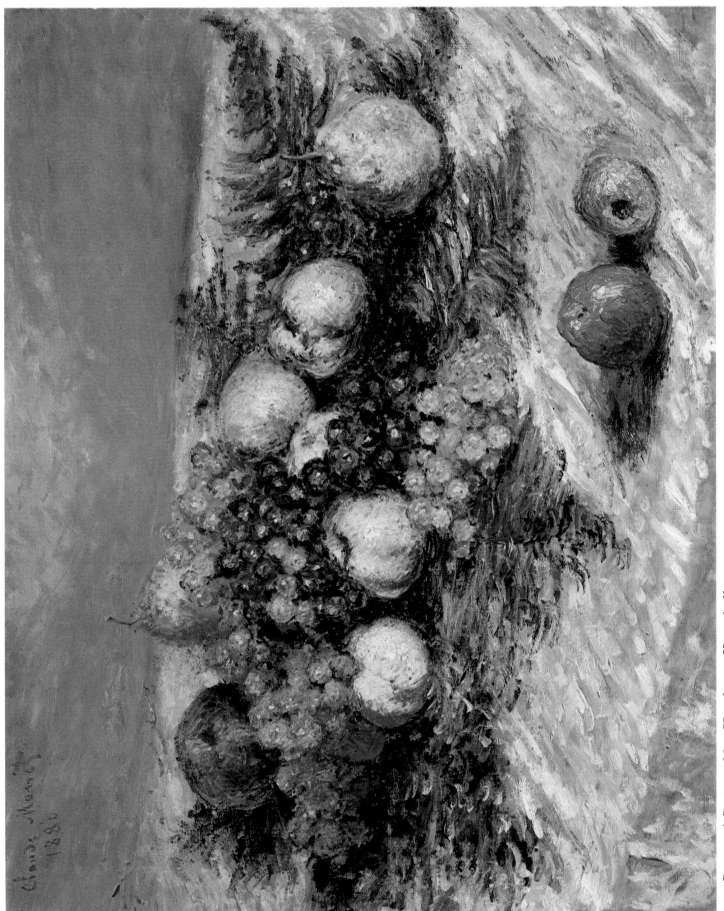

23. *Pears and Grapes*. 1880. Hamburg, Kunsthalle.

24. *Vétheuil in the Fog*. 1879. Paris, Musée Marmottan.

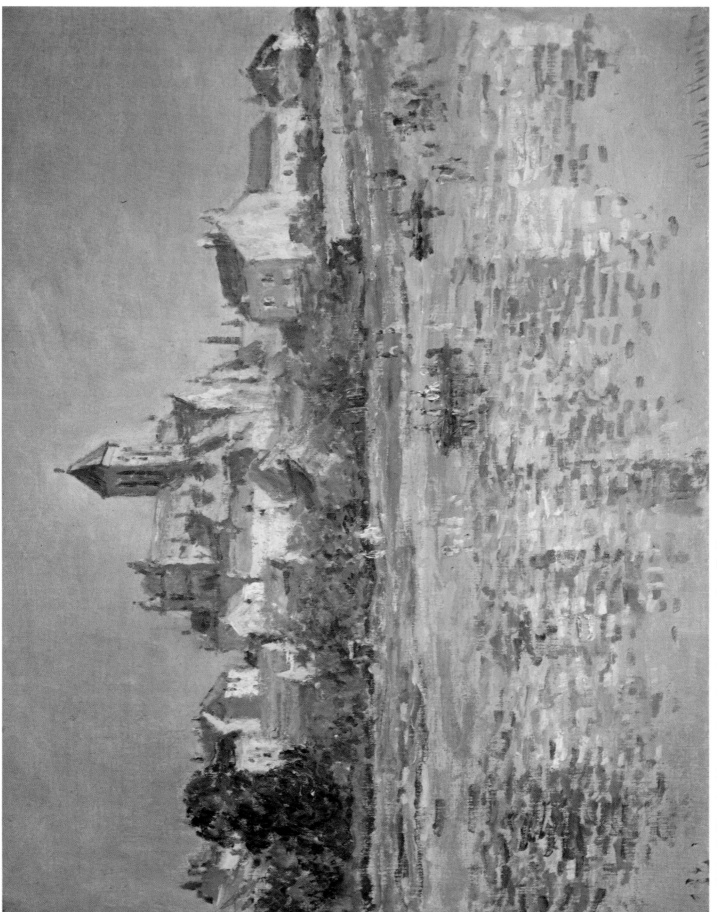

25. *Vétheuil Church*. About 1879. Southampton, Art Gallery.

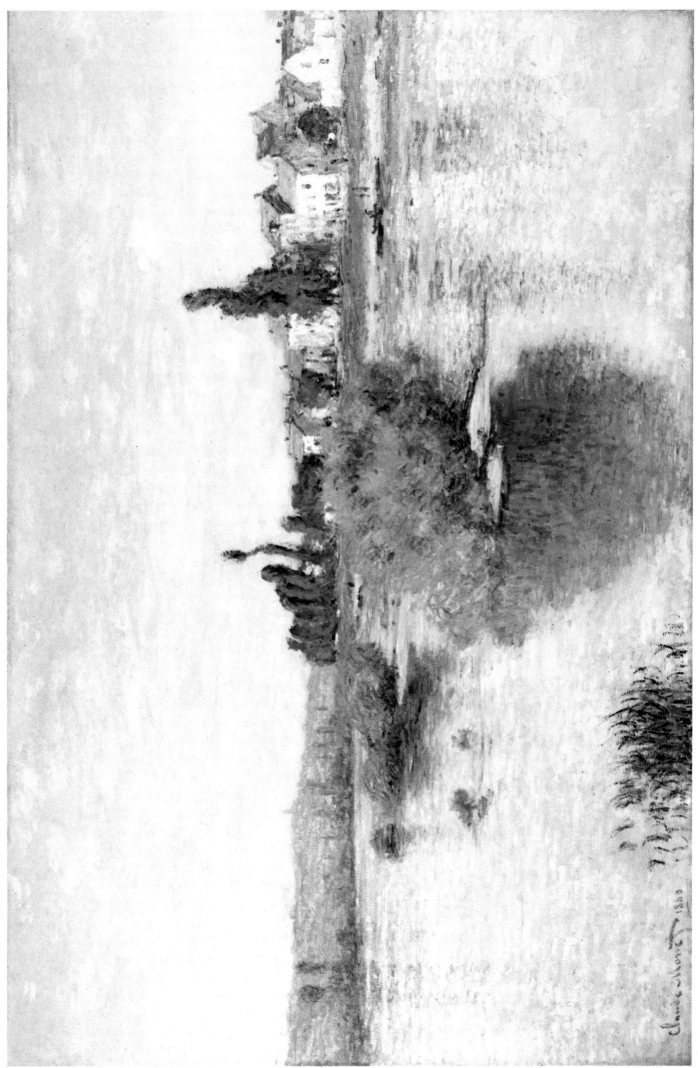

26. *Lavacourt*. 1880. Dallas, Museum of Fine Arts.

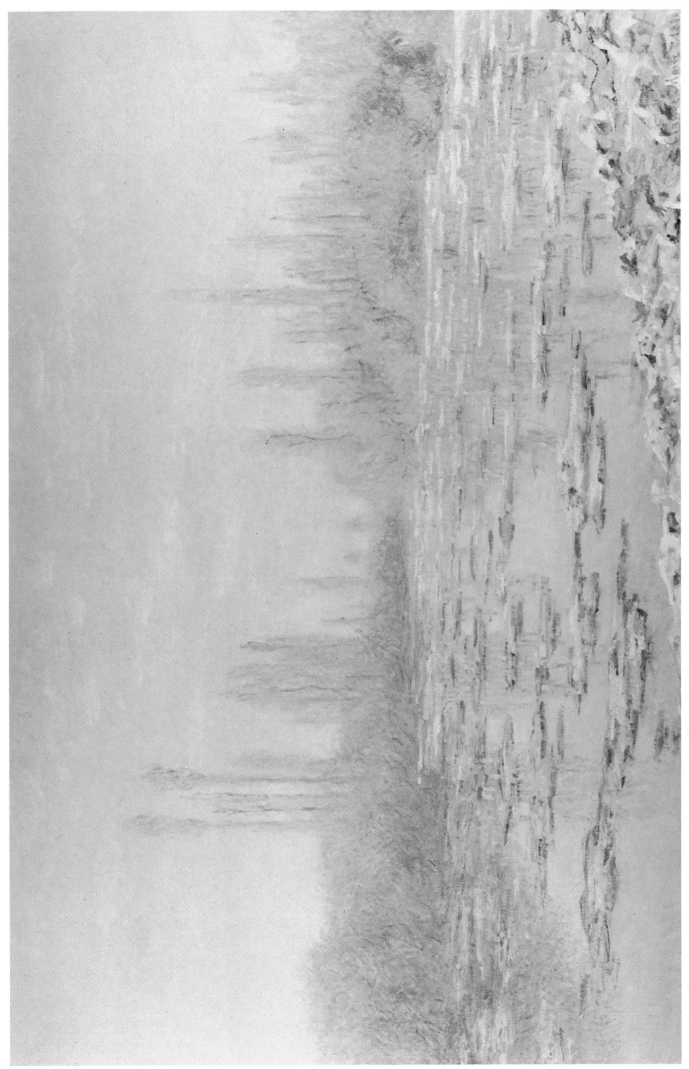

27. *The Ice-Floes.* 1880. Shelburne, Vermont, Shelburne Museum.

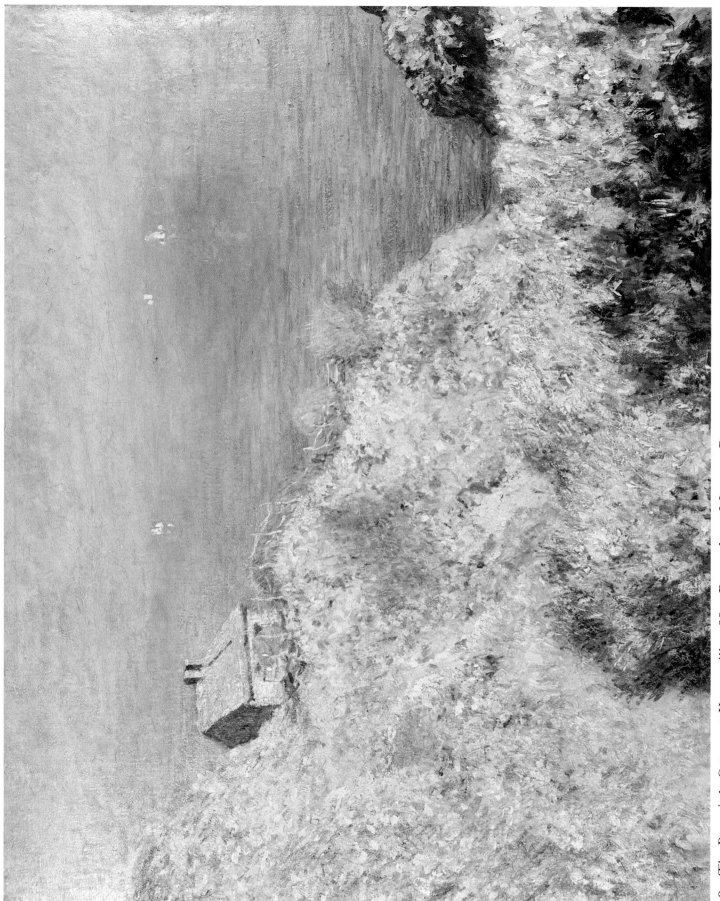

28. *The Douanier's Cottage at Varengeville.* 1882. Rotterdam, Museum Boymans.

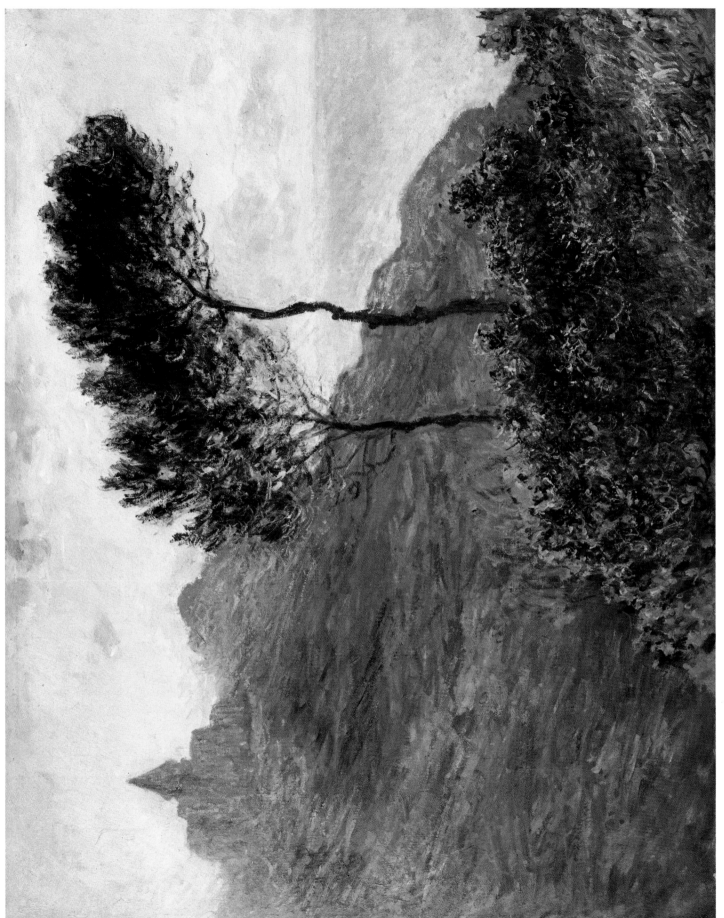

29. *Varengeville Church.* 1882. Birmingham, Barber Institute of Fine Arts.

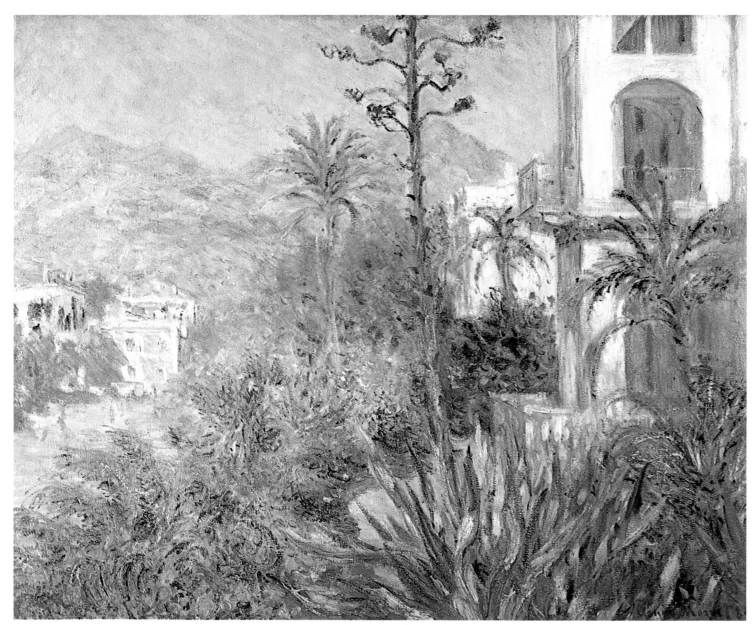

30. *Bordighera*. 1884. Santa Barbara, California, Museum of Art.

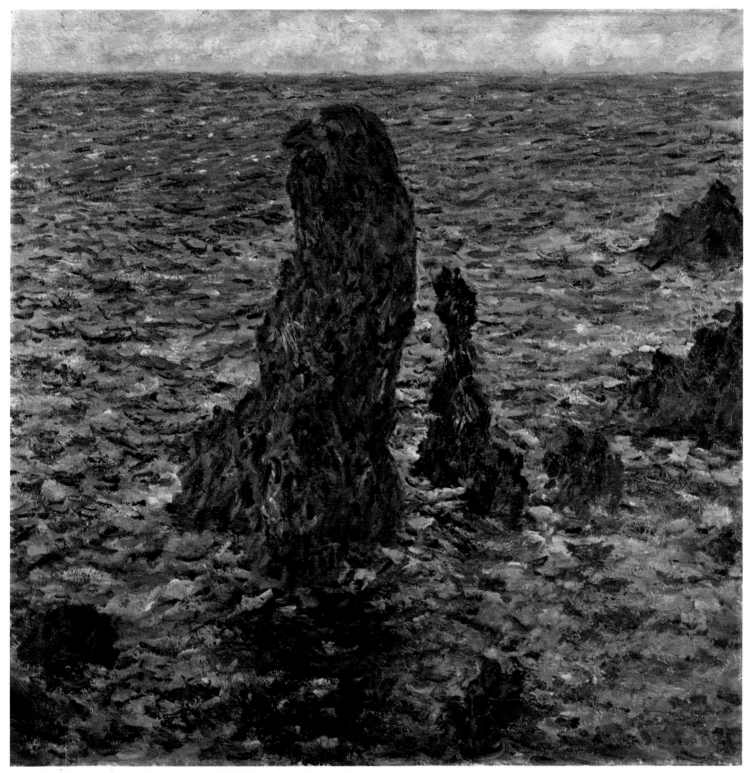

31. *The Pyramides at Port-Coton.* 1886. Private Collection.

32. *Spring.* 1886. Fitzwilliam Museum, Cambridge.

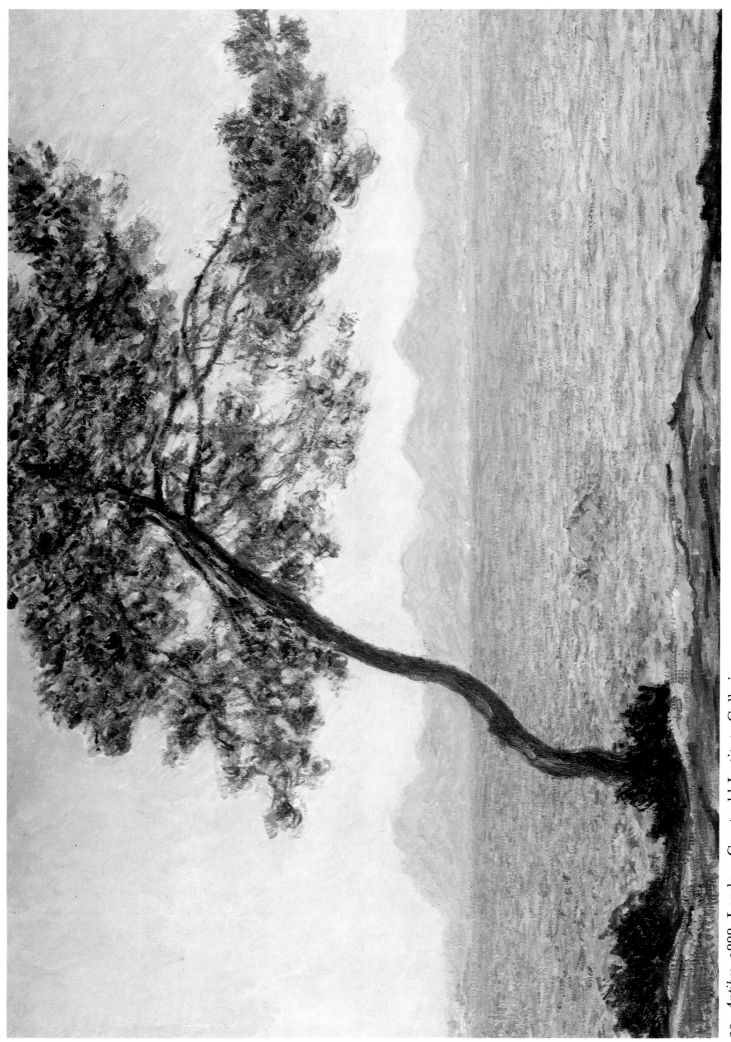

33. *Antibes.* 1888. London, Courtauld Institute Galleries.

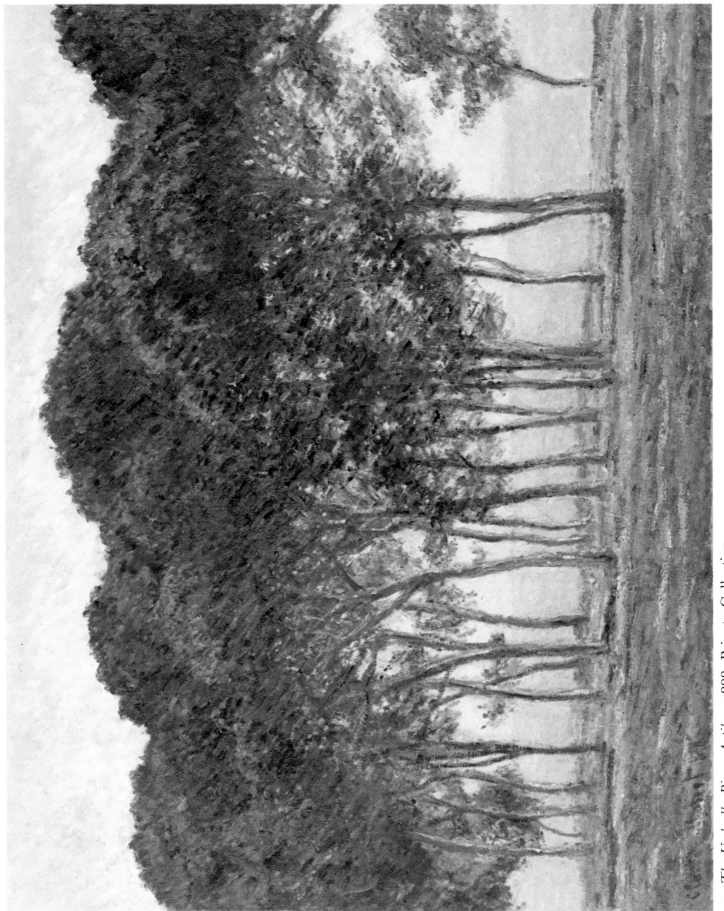

34. *The Umbrella Pines, Antibes.* 1888. Private Collection.

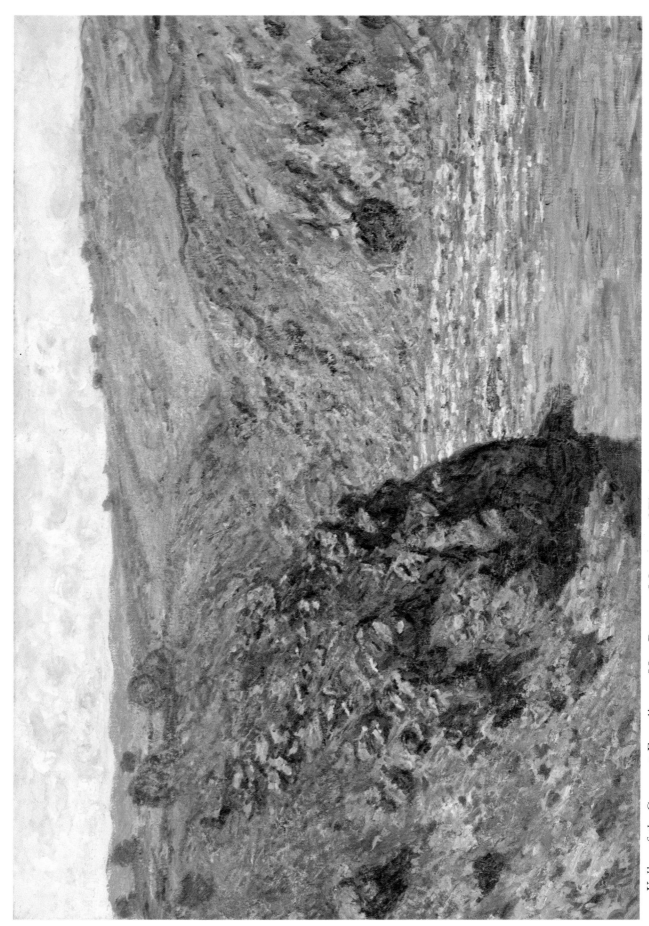

35. *Valley of the Creuse at Fresselines.* 1889. Boston, Museum of Fine Arts.

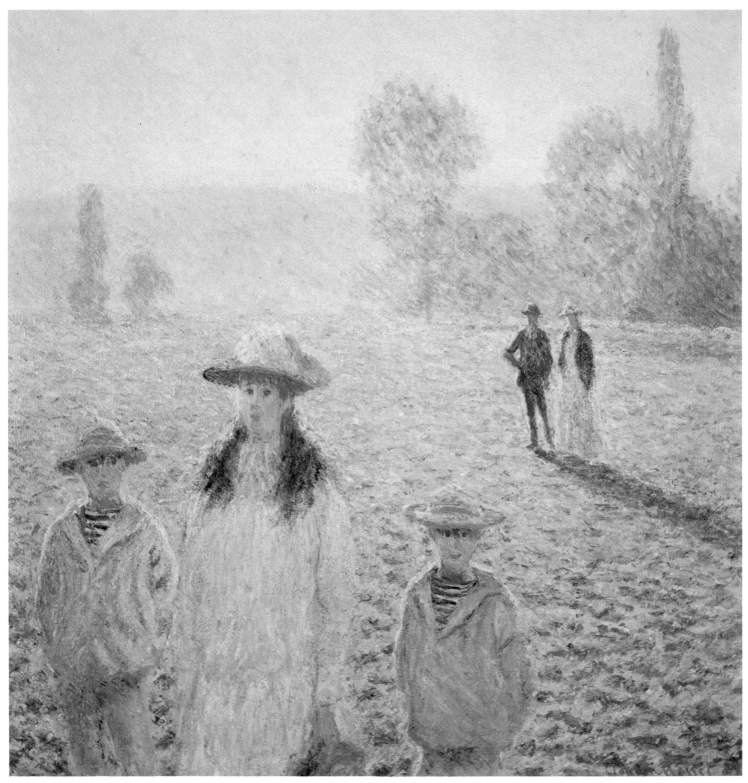

36. *Five Figures in a Field*. 1888. Private Collection.

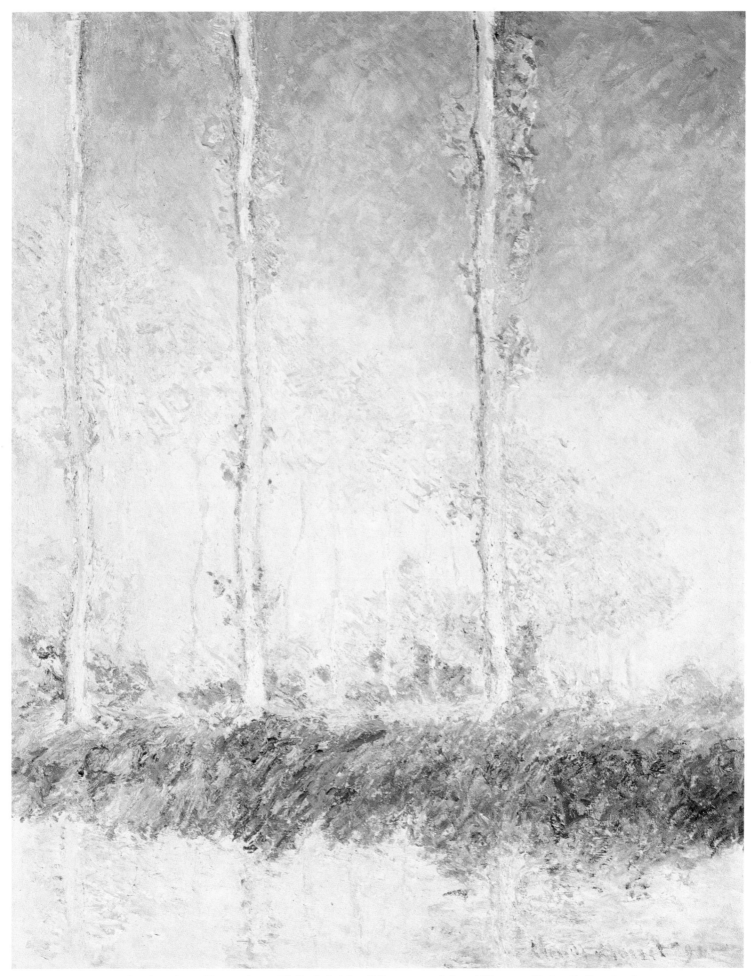

37. *Poplars on the Banks of the Epte.* 1891. Philadelphia, Museum of Art (Chester Dale Collection).

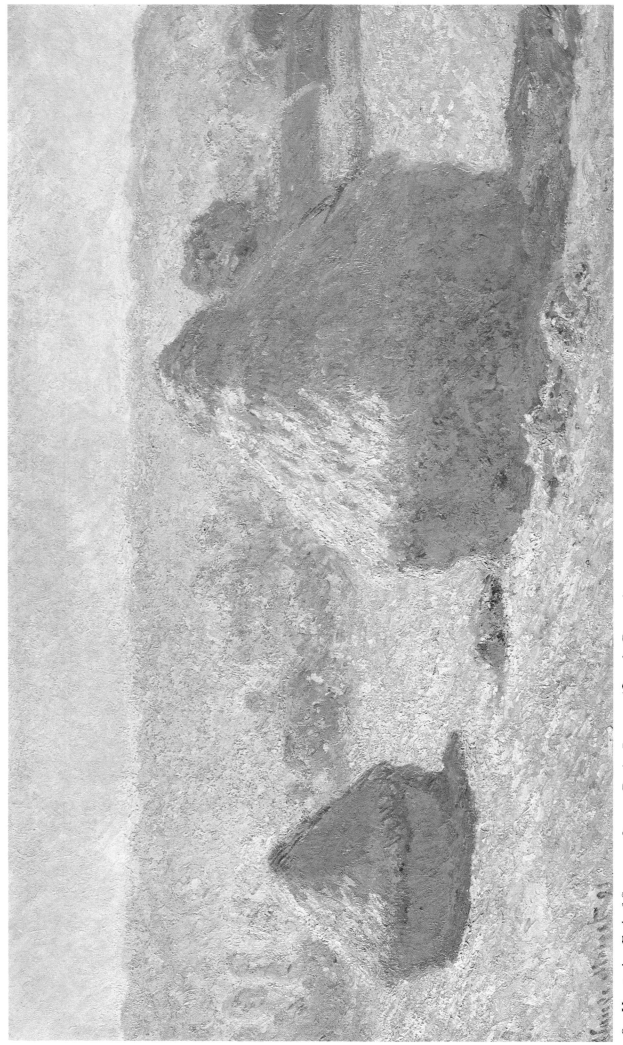

38. *Haystacks, End of Summer.* 1890-1. Paris, Louvre (Jeu de Paume).

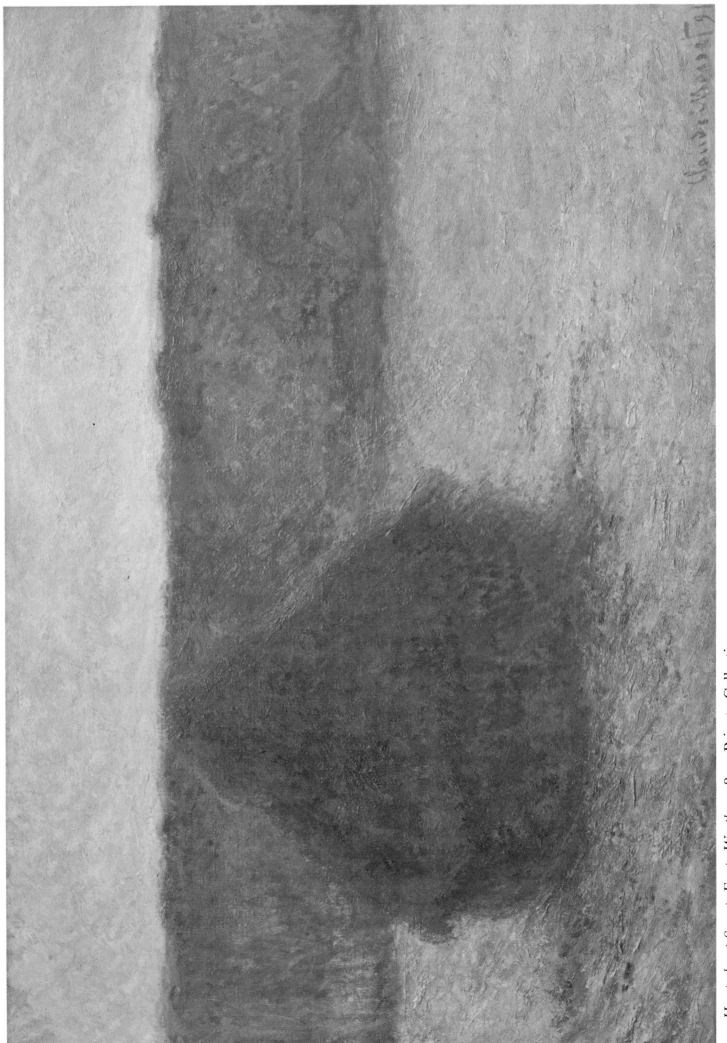

39. *Haystacks at Sunset, Frosty Weather*. 1891. Private Collection.

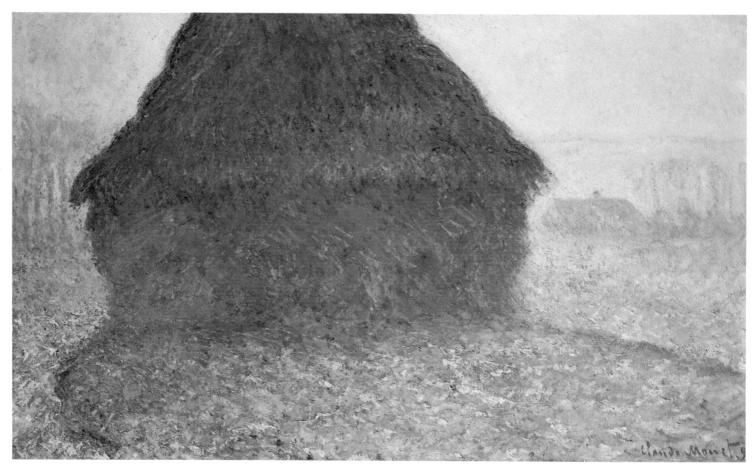

40. *The Haystack*. 1891. Kunsthaus, Zürich.

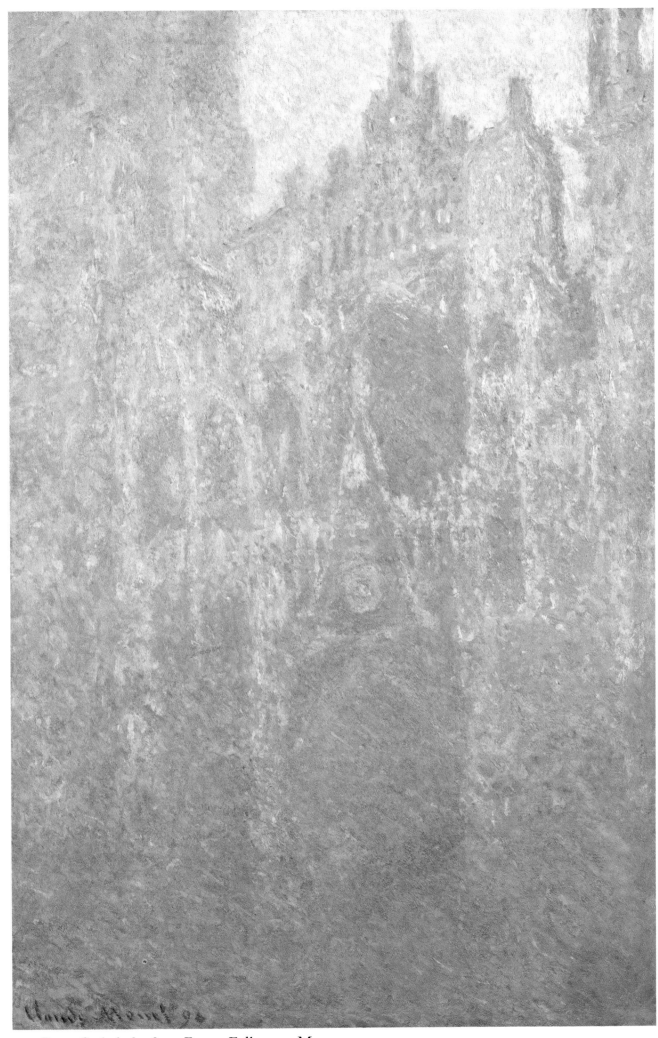

41. *Rouen Cathedral*. 1894. Essen, Folkwang Museum.

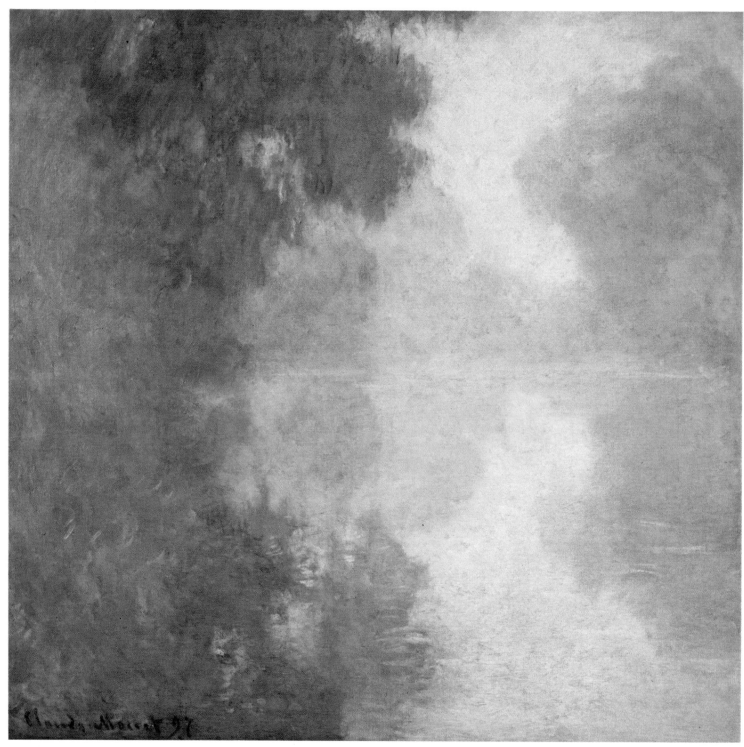

42. *Morning Mists.* 1897. Private Collection.

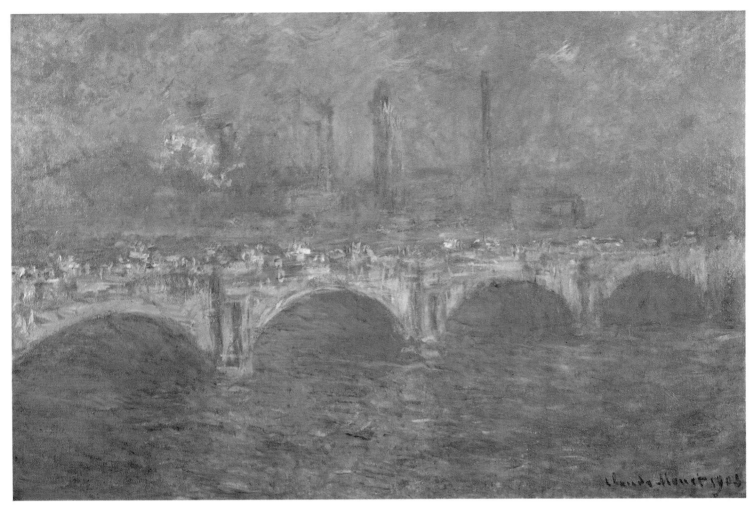

43. *Waterloo Bridge.* 1903. Pittsburgh, Carnegie Institute.

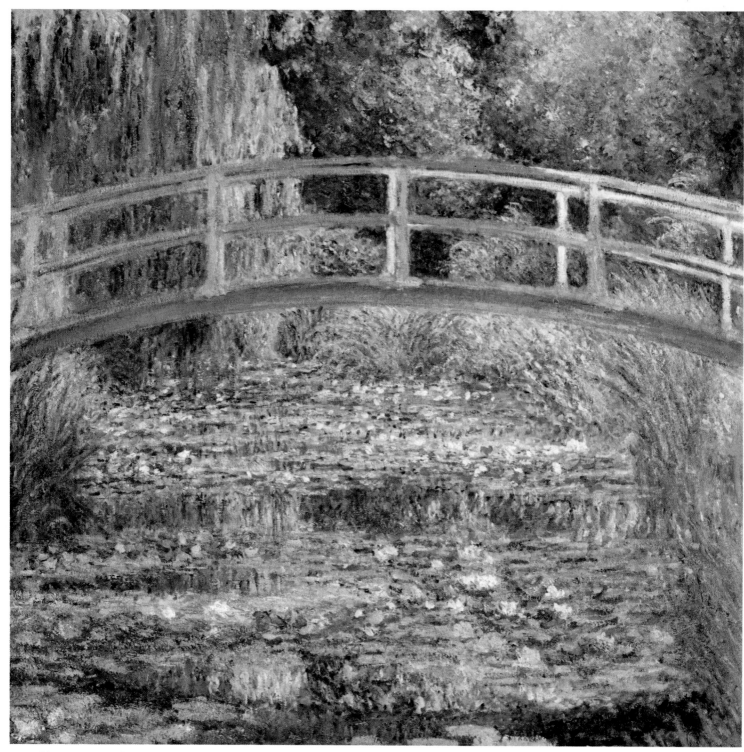

44. *The Lily Pond.* 1899. London, National Gallery.

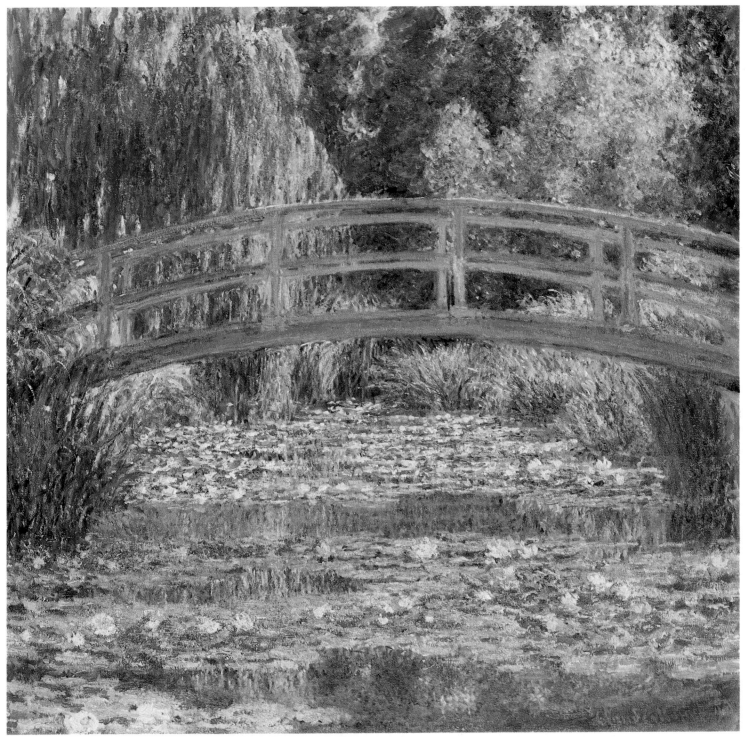

45. *The Japanese Footbridge.* 1899. Philadelphia, Museum of Art.

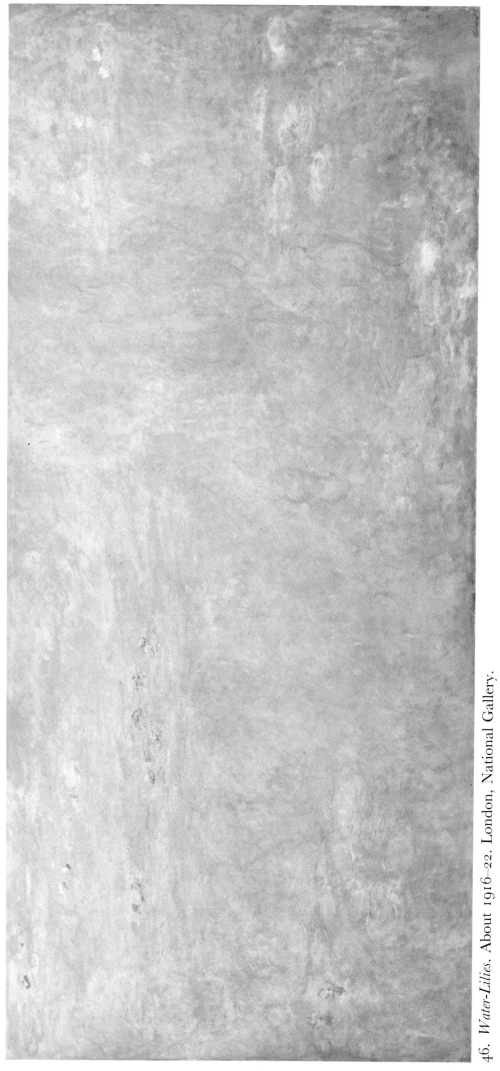

46. *Water-Lilies*. About 1916–22. London, National Gallery.

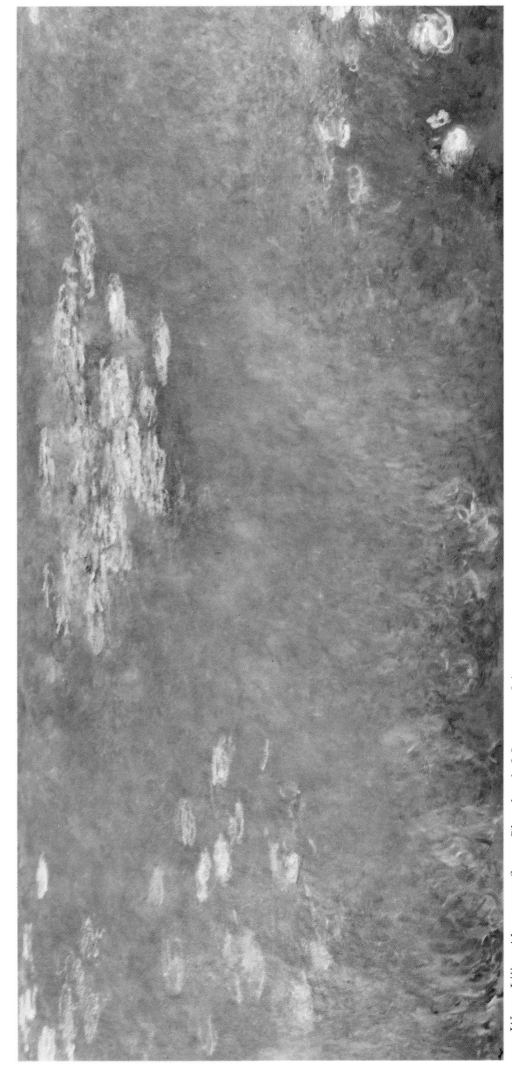

47. *Water-Lilies*. About 1916-22. Cleveland, Museum of Art.

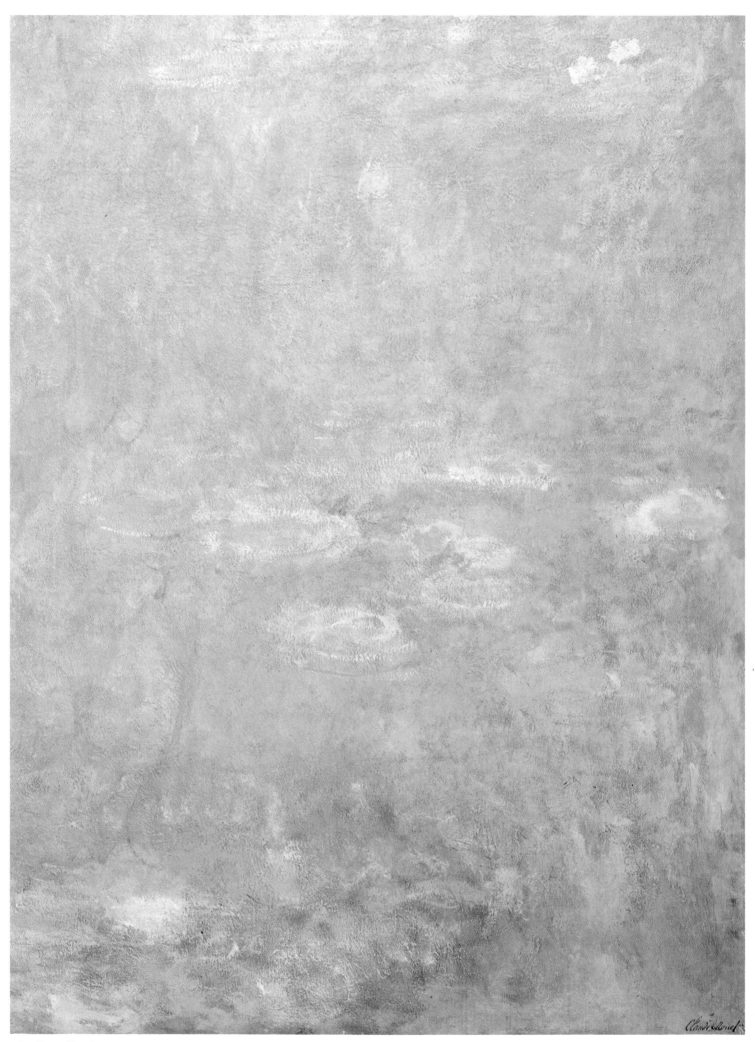

48. Detail of Plate 46.